IMAGES
of Rail

THE RAILROAD
AT POCATELLO

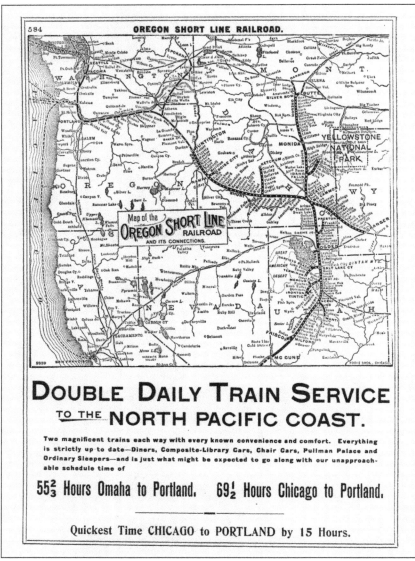

This map of the Oregon Short Line Railroad from the 1901 issue of *The Official Guide of the Railways* shows Pocatello as the junction of rail lines from all four directions of the compass. Because of its strategic location, Pocatello became an important division point where trains were serviced, maintained, and repaired. When this map was published, the Oregon Short Line Railroad, which was a subsidiary of the Union Pacific Railroad, was building a network of branch lines throughout southern Idaho. (Thornton Waite collection.)

ON THE COVER: The shop crew, including their dog on the right, is posing in front of a wooden Oregon Short Line caboose at the east end of the car shop in this 1910 photograph. The shop building was constructed in 1905 and became the steel car shop following the completion of the new coach, tender, and boiler shop in 1914. True railroaders of the era, the men were all wearing hats—only the woman has her hat removed. Coach shop foreman J.W. Blackburn is the man standing on the extreme right. The railroad provided good, well-paying jobs for up to a quarter of the Pocatello residents. (Thornton Waite collection.)

IMAGES
of Rail

THE RAILROAD AT POCATELLO

Thornton Waite

ARCADIA
PUBLISHING

Published by Arcadia Publishing
Charleston, South Carolina

Library of Congress Control Number: 2011927879

For all general information, please contact Arcadia Publishing:
Telephone 843-853-2070
Fax 843-853-0044
E-mail sales@arcadiapublishing.com
For customer service and orders:
Toll-Free 1-888-313-2665

Visit us on the Internet at www.arcadiapublishing.com

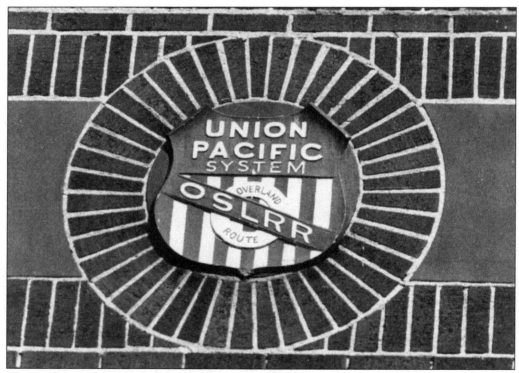

The Oregon Short Line Railroad insignia using the well-known Union Pacific shield can still be seen on the front of the Pocatello depot. Built into the depot facade, this shield dates back to 1915 when the depot was first opened and the Oregon Short Line was operated as a separate subsidiary of the Union Pacific Railroad. (Photography by Thornton Waite.)

CONTENTS

ACKNOWLEDGMENTS

This book would not have been possible without the help of many people. The late John Sorensen was fascinated by the history of Pocatello and the Union Pacific Railroad, and he shared his knowledge of the history of the railroad in Pocatello with me. Before he passed away, Clifford Peake, who also worked for the Union Pacific Railroad, generously loaned me photographs that he had collected, helping me learn more about the history of the Union Pacific Railroad in Idaho. The late Pete Petersen, who worked for the railroad and came from a railroad family, collected numerous photographs of the railroad in Pocatello, and I have used many of the images that he had in his collection. George Cockle also provided some of the photographs from his collection for this book. Thank you to John Bromley for permission to use prints from the Union Pacific Museum and to John Aguirre and Fred Dykes, who were kind enough to let me use photographs from their collections. The members of the Pocatello Model Railroad and Historical Society provided the photographs of the icehouse, images I had never seen before. The group has a wonderful model railroad layout in the old railroad bus garage next to the Pocatello depot. Thanks to Coleen Balent, of Arcadia Publishing, for helping me get this book prepared for printing. Again, thanks to my sister Corinne Waite, who read through my manuscript to see if it made sense. Thank you all—without your help, this book would not have been possible. Of course, I do take all responsibility for any errors or omissions. Unless otherwise noted, all images are from the collection of the author.

INTRODUCTION

The heritage and history of Pocatello and the Union Pacific Railroad are closely related and form a fascinating part of Idaho's history. Since its founding in the southeastern corner of the state, Pocatello, Idaho, has always been an important railroad town on the Union Pacific Railroad. Both the economy and development of the town have been influenced by the railroad ever since the first trains arrived in 1878. Located 135 miles north of Ogden, Utah, and 214 miles west of Granger, Wyoming, Pocatello has been a crew change point and was the site of one of the Union Pacific Railroad's biggest shops for many years. Even today, the town is literally divided by the railroad tracks, and the railroad employs several hundred men and women to run and service the trains.

At an elevation of 4,447 feet above sea level, Pocatello is on the eastern edge of the Snake River Plain. The city is situated at the west entrance to the Portneuf Canyon, the easiest way through the mountains from Wyoming to the Pacific Northwest. This route through the canyon was originally part of the Oregon Trail, and a freight stage line went through the canyon on the route between Salt Lake City and the mines in Montana by 1863. The Snake River bottoms to the west of what is now Pocatello were a favored location to stop for water, feed, and protection from the weather, while the Portneuf Canyon was a favored spot for road agents because of the rugged mountains that provided places to hide out from the law.

The location was named after Shoshone Indian Chief Pocatello, who was born in Utah in 1815 and died in 1885. In the 1850s, Chief Pocatello led attacks against white settlers, and it was not until the signing of the Fort Bridger Treaty of 1868 that he stopped attacking the settlers and agreed to move his people onto the Fort Hall Indian Reservation in southeastern Idaho. Chief Pocatello granted the right-of-way to the narrow gauge Utah & Northern Railway across the Fort Hall Indian Reservation, aided in part by the offer of free train rides for the Indians living on the reservation, a privilege that lasted until 1908. Following this agreement, the Utah & Northern Railway built its line through the reservation in 1878.

The Utah & Northern Railway Company was merged with the Oregon Short Line and several other Union Pacific–owned subsidiaries to form the Oregon Short Line & Utah Northern Railway Company (OSL&UN) in 1889. The OSL&UN entered bankruptcy due to the depression of 1893, shortly after the Union Pacific went into receivership, and was reorganized as the Oregon Short Line Railroad Company in 1898. In 1938, the Oregon Short Line was leased to the Union Pacific, and in 1987, the Oregon Short Line was merged into the Union Pacific, officially ending the separate identity of the Oregon Short Line.

The first branch line in southern Idaho was constructed in 1884 by the Oregon Short Line. It was built north from the main line at Shoshone to reach the mines in the Ketchum area when the railroad was being built across southern Idaho. Under the direction of E.H. Harriman, the Union Pacific began an aggressive expansion program at the beginning of the 20th century to promote the development and growth of the railroad on the Snake River Plain in southern Idaho

by building numerous branch lines. The branch lines all funneled their traffic through Pocatello, helping the city grow and prosper.

The Oregon Short Line expanded and prospered over the years so that bigger and better facilities were built all along the railroad. The railroad shops at Pocatello were some of the biggest on the Union Pacific lines west of Omaha, the railroad headquarters. Traffic boomed in the 1920s, with the railroad reporting an average of 75 trains a day through Pocatello in 1929. However, the traffic dropped during the Great Depression years and then exploded during World War II. In the years immediately after the war, the railroad employed over 3,000 men and women in Pocatello, with the number depending on the season. In 1947, the railroad built a large gravity switching yard, the first one to use retarders on the Union Pacific, to handle the large number of freight cars. Over the following years, much of the time-sensitive freight business went over to highway trucks, but Pocatello remained busy transporting freight to and from the Pacific Northwest, potatoes and grain grown in the area, phosphate ores from the nearby mines on the Fort Hall Indian Reservation and at Soda Springs, and mine products from Montana.

Famous-name passenger trains, such as the *Portland Rose*, the *City of Portland*, and the *Yellowstone Special* as well as numerous local trains once stopped at Pocatello. However, passenger service through Pocatello ended on May 1, 1971, when Amtrak took over the nation's rail passenger service. Amtrak inaugurated the *Pioneer*, a passenger train through Pocatello to Portland and Seattle, in 1977, but it was discontinued in 1997 after many years of sporadic interest and support.

Technology has changed the face of the railroad over the years. Labor-intensive steam locomotives were replaced by more efficient diesel-electric locomotives, which did not require the large shops in Pocatello. The tie plant was razed in the late 1940s when it was no longer needed to treat railroad ties with preservatives, and the icing plant was closed with the advent of mechanical refrigerator cars, which did not require ice. Unit trains eliminated the need to sort as many cars at Pocatello, and the container and trailer trains took away much of the business formerly shipped in single carloads. However, freight trains continue to arrive and depart at Pocatello 24 hours a day. There are freight trains on the railroad's busy main line east to Wyoming and west across southern Idaho to Oregon and Washington. Additional trains run north to Idaho Falls and Silver Bow, Montana, and south to Ogden, Utah.

The Union Pacific has merged with several other railroad companies, including the Western Pacific, the Southern Pacific, the Missouri, Kansas & Texas, the Chicago & North Western, and the Denver & Rio Grande Western, and it is one of the largest railroad companies in the country today. Although the railroad, which once employed one-fourth of the town's population, now only employs a few hundred men and women in the city, it still has a significant impact on the local economy.

Residents in Pocatello are justifiably proud of their railroad history and heritage. The photographs in this book show why and how the railroad has been so important to Pocatello over the years.

One

ARRIVAL OF THE
RAILROAD

The narrow gauge Utah & Northern Railway Company passed through what is now Pocatello on its route north to Montana, reaching Pocatello Creek in August 1878. The route through Pocatello went across what is now the Idaho State University campus. Joseph E. Edson settled in an old boxcar that had been set off by the side of the tracks on the south side of Pocatello Creek. The boxcar served as a residence and depot where Edson worked as the telegrapher. He was later chief dispatcher for the Utah & Northern.

A water tank and coal bin were soon constructed by the tracks with the water being obtained from nearby Pocatello Creek. In a short period of time other railroad workers settled here, living by the tracks in tents or shacks. Available land was limited because the route went through the Fort Hall Indian Reservation, and the railroad only had title to a narrow, 200-foot-wide right-of-way.

When the standard gauge Oregon Short Line Railway was built through southern Idaho in 1881, the freight was initially transferred between the standard gauge Oregon Short Line Railroad and the narrow gauge Utah & Northern Railway to the east at McCammon Junction. The Oregon Short Line originally planned to build its shops at this location, but H.O. Harkness, the owner of the property at McCammon Junction, objected to the railroad's use of the land, so the Oregon Short Line moved its facilities to Pocatello Creek. The Utah & Northern purchased 40 acres of land from the Shoshone and Bannock Indian tribes for the Pocatello facilities.

In 1887, the railroad moved its shops from Eagle Rock south to Pocatello and shortly thereafter moved the shops from Shoshone to Pocatello. The railroad needed more land for the expanding railroad facilities, so it purchased another 1,840 acres on the Fort Hall Indian Reservation. After Pocatello was incorporated as a village in the spring of 1889, permanent buildings were constructed, since the residents and businesses could now own land. Pocatello continued to grow and was incorporated as a city in 1893.

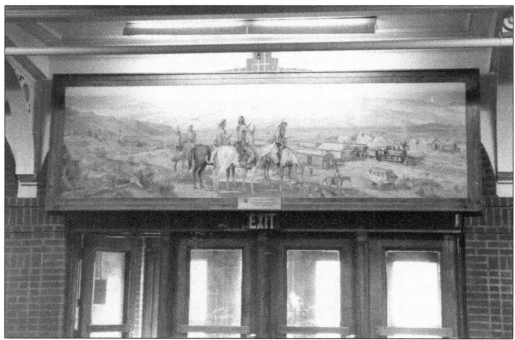

Painted using some artistic license, this mural shows Chief Pocatello on his horse watching one of the first Utah & Northern Railway trains passing through Pocatello. The mural was once over the main entrance to the waiting room of the Pocatello depot and is now at the Stephens Performing Arts Center on the Idaho State University campus.

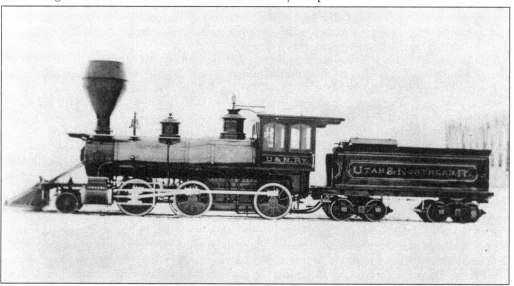

The narrow gauge Utah & Northern Railway used small 2-6-0 Moguls, such as this one, to pull their passenger and freight trains. These locomotives were built by the Baldwin Locomotive Works in the late 1870s and early 1880s. The narrow gauge Utah & Northern was widened to standard gauge between Pocatello and Montana in one day on July 24, 1887, and from Pocatello south to Utah in the summer of 1890.

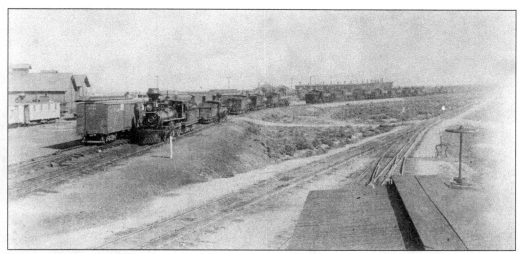

This photograph was taken about 1887, the year the narrow gauge line north of Pocatello was widened to standard gauge, and it shows both standard gauge and narrow gauge locomotives being stored on the tracks. The roundhouse is in the background with some cabooses on the left. The complexity of the three-rail tracks used for both narrow gauge and standard gauge trains made operations at Pocatello a challenge.

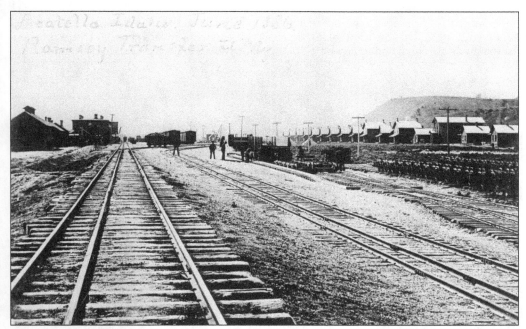

After the Oregon Short Line built across southern Idaho, the narrow gauge Utah & Northern and standard gauge Oregon Short Line interchanged freight cars at Pocatello. A special piece of equipment known as the Ramsey Transfer (seen on the right) was used to exchange the standard gauge and narrow gauge trucks under the railroad cars. The employee residences are on the right, and the railroad depot and other facilities are on the left. The three rails allowed the standard gauge and narrow gauge trains to use the same tracks.

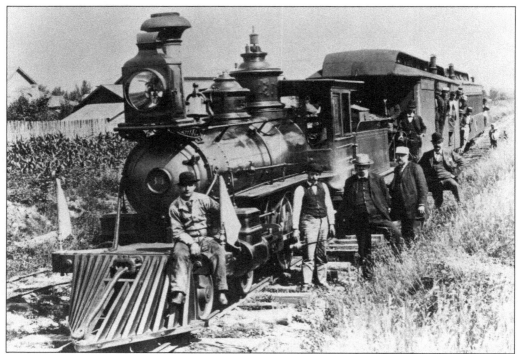

This is reportedly the last narrow gauge train to run to Pocatello on the Utah & Northern; the image was taken in 1890. The line south of Pocatello was widened to standard gauge in that year when the route was upgraded and improved. (Union Pacific Museum/George Cockle collection.)

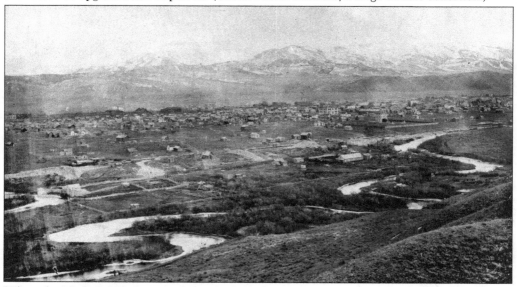

When the Utah & Northern built north through what is now Pocatello, it passed through the Fort Hall Indian Reservation. Situated on the Snake River Plain, the land was high desert country covered with sagebrush. This view of Pocatello was taken about 1894, shortly after it had been incorporated as a city. Solid, permanent buildings were constructed once the land could be owned by the residents and businessmen. The depot and railroad facilities are in the far background.

In 1909, the Oregon Short Line and the Pocatello Commercial Club worked together to publish this brochure extolling the virtues of the area. The railroad actively promoted the growth and development of southern Idaho since it increased the passenger and freight revenues.

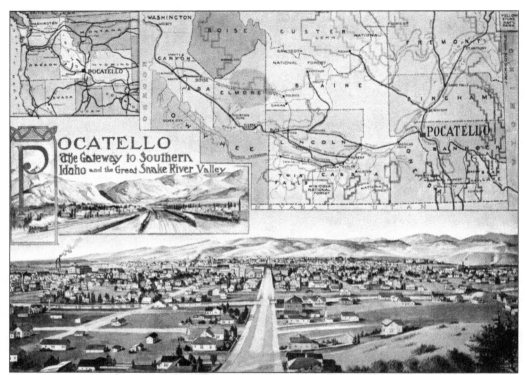

Shown is an artist's view of Pocatello at the beginning of the 20th century. By this time, many of the branch lines had been built in southern Idaho. The lines to Victor in eastern Idaho and to Hill City in central Idaho had not yet been completed, while some of the other proposed lines were never built.

Two

THE FIRST DEPOTS

Because of its location, Pocatello has always been a major railroad interchange point for both passenger and freight cars. The city has had four different passenger depots to handle the passenger traffic since the first Utah & Northern train arrived. The first "depot" at Pocatello was an old boxcar used by the first railroad employee, Joseph Edson. It was placed by the side of the tracks at Pocatello Creek when the Utah & Northern Railway built its line through the area in 1878 on the way north to Montana.

The first real depot building in Pocatello was the Pacific Hotel, also known as the Keeney House. Opened in 1883, it was used by both the Oregon Short Line and the Utah & Northern. Dining facilities, a waiting room, and a ticket office were on the first floor while the second floor held railroad offices and hotel rooms.

Because of the increasing business, the railroad opened a new wood-framed depot next to the hotel in 1886. It had additional space for the railroad business and was more suitable for the train operations. The building held a waiting room, a baggage and express room, and offices, and was used for many years. However, in later years, the waiting room was apparently moved out of this building back into the Pacific Hotel facilities to provide more space in the railroad depot for express and baggage.

In the years prior to World War I, the railroad was under increasing pressure to build a new, modern depot to replace the old wooden 1886 structure, which was old, too small, and worn out. The wood depot was in such bad shape that the Idaho attorney general sued the Oregon Short Line on behalf of the Idaho Public Utilities Commission because of the "unsafe, insanitary and dilapidated condition" of the depot. The action was deferred by the attorney general when the railroad informed him that a new depot was to be built. The fourth depot was opened in 1915 and is still standing and in use by the Union Pacific Railroad.

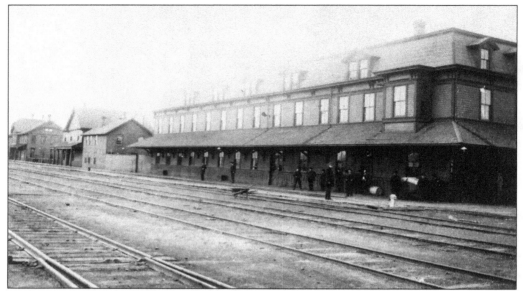

After it was opened in 1883, the Pacific Hotel was used by both the Oregon Short Line and the Utah & Northern for their passenger depot. The first floor had a waiting room, dining facilities, and a kitchen, and the upper floors held railroad offices and lodging facilities.

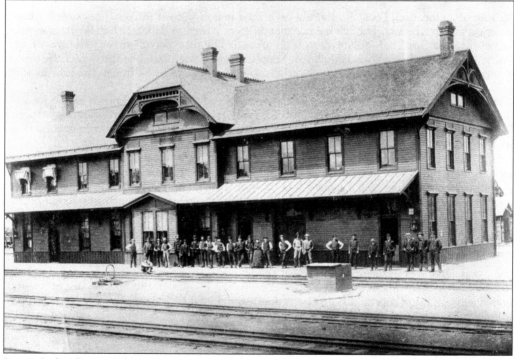

In 1886, the Oregon Short Line opened their railroad depot a short distance to the west of the Pacific Hotel. The first floor had a waiting room, baggage and express facilities, and a ticket office, and the second floor had space for the railroad officials and dispatchers. (Union Pacific Museum collection.)

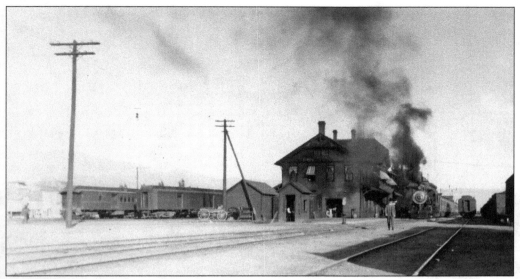

A westbound train is arriving at the Pocatello depot in 1905. The tracks north to Montana are on the left side of the depot, and the front of the Pacific Hotel can be seen behind the steam locomotive. The man sitting in the flagman's house in front of the depot warned the pedestrians walking across the tracks of approaching trains.

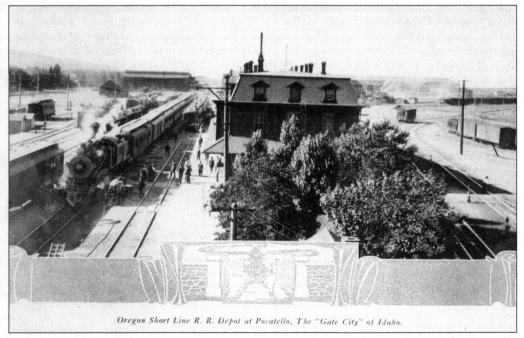

Oregon Short Line R. R. Depot at Pocatello, The "Gate City" of Idaho.

It is about 1908, and there are two passenger trains on the main line in front of the Pocatello depot. The Pacific Hotel is the building in the foreground, and the tracks to the yards and engine facilities can be seen behind the hotel. There was a small lawn and park in the front of the hotel in the middle of the busy railroad facilities.

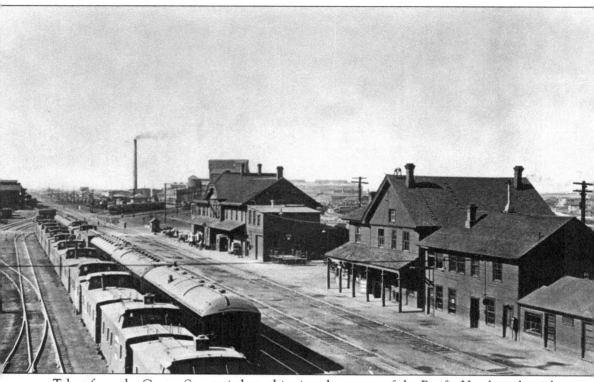

Taken from the Center Street viaduct, this view shows part of the Pacific Hotel on the right and the Pocatello depot on the left. There are several loaded baggage carts in front of the depot, and the pathway at the Lander Street crossing is just beyond the depot in front of the flagman's house. The shops are in the background, and the cabooses on the left are waiting for their next assignment. (Union Pacific Museum collection.)

Three

THE 1915 DEPOT

Opened in 1915, the present Beaux Arts depot building in Pocatello was designed by the New York City architectural firm of Carrêre and Hastings. Although the Union Pacific Railroad designed and built the small depots along their lines using standardized designs, they commissioned Carrère and Hastings to design the new Pocatello depot because it was at an important railroad junction. The firm began working for the railroad following its design of the Arden Estate (1905–1910) outside of New York City for Union Pacific Railroad president E.H. Harriman. The firm later designed the depots at Grand Island and North Platte in 1918 for the railroad in the same Beaux Arts architectural style. The firm of Carrêre, Hastings, Shreve, and Lamb designed the Mission-style depot at Boise, which opened in 1925 following the completion of the main line through that city.

On August 20, 1915, the Pocatello depot was officially opened to an enthusiastic crowd. A parade was followed by speeches, a street carnival, and dancing in the waiting room that lasted until well past midnight. The brick and stone building had a three-story center section measuring 77 feet by 84 feet with two 60-foot-by-68-foot wings. When the depot was opened, the first floor contained the conventional facilities associated with a station at that time. The waiting room was 41 feet by 89 feet with oak benches surrounded by a balcony on the second floor. The ticket office was across the waiting room from the main entrance, flanked by exits to the tracks. There was a newsstand on one side of the waiting room, and the depot master's office was on the other side. The lunchroom, dining room, kitchen, and pantry were in the west wing, and the east wing contained an emigrants' waiting room, the baggage office, the express room, and the mail clerk's office. The second floor held the offices of the Montana and Idaho divisions and telegrapher offices.

When Amtrak began operation of the *Pioneer* through Pocatello in 1977 it maintained a ticket office in the depot for several years. The depot continues to be used by the railroad today for a variety of purposes and is part of downtown Pocatello at the intersection of Harrison Avenue and West Bonneville Street.

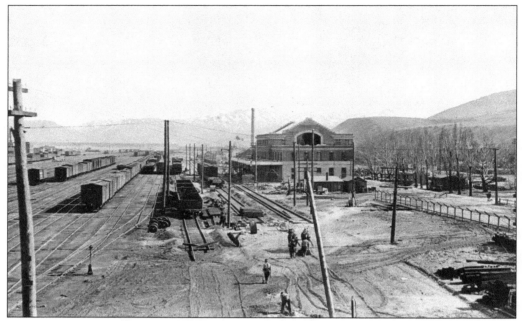

This is a trackside view looking east from the Center Street viaduct showing the Pocatello depot while it is being constructed. The mainline tracks are in the process of being rerouted so they pass in front of the new building. The Portneuf Gap can be seen in the background behind the new depot building.

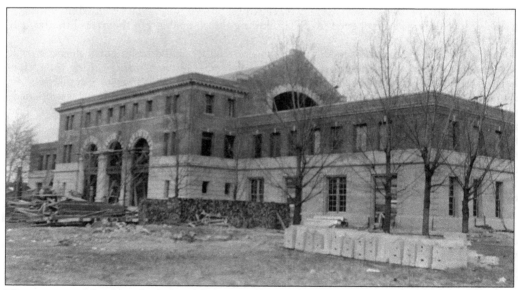

The exterior of the depot had almost been completed when this photograph was taken, although there is still a lot of construction material staged in the front of the building. The trees were apparently left in place around the building during construction.

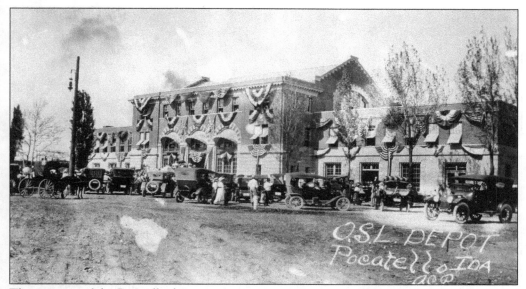

The opening of the Pocatello depot on August 20, 1915, was justification for a large parade and celebration. This view of the opening day of the new depot at Pocatello shows horse-drawn wagons and automobiles all parked haphazardly in front of the main entrance. The depot building has been covered with patriotic red, white, and blue banners.

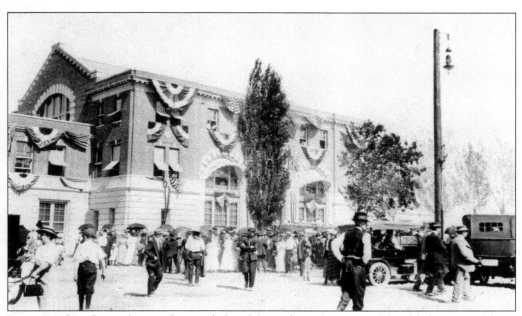

Large crowds gather at the new depot to help celebrate the replacement of the old, dingy wood depot building. Pocatello now had a depot that would make a good impression on arriving travelers.

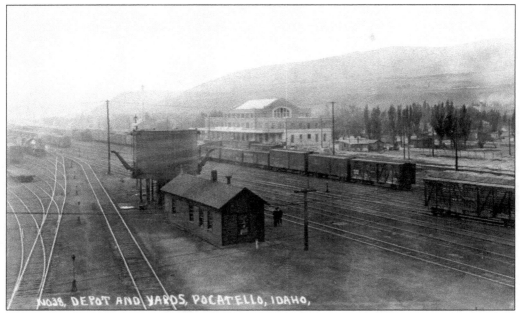

This view of the Pocatello depot was taken while it was under construction. The water tank in the foreground was used by steam locomotives on two different tracks. The yard tracks for the freight trains are in front of the new depot.

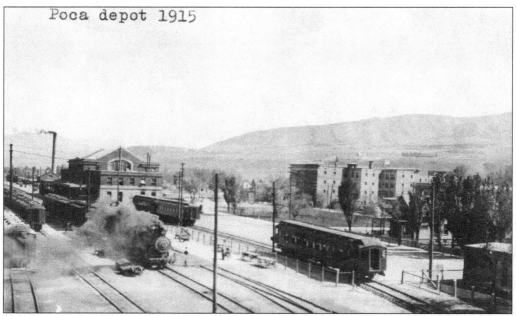

Taken shortly after the Pocatello depot was opened, a short passenger train is headed by a steam locomotive putting out a large plume of smoke. A few passenger cars are spotted on the business track to the right side of the depot. The newly opened Yellowstone Hotel is just above the passenger car on the right.

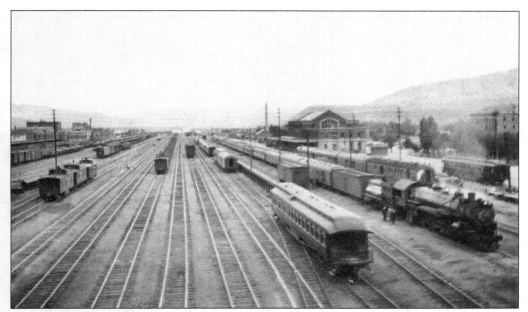

It is about 1919, and a long westbound train is stopped at the Pocatello depot while a local train is on the right waiting for a steam locomotive. This view was taken from the Center Street viaduct and shows the extensive yard tracks in front of the depot.

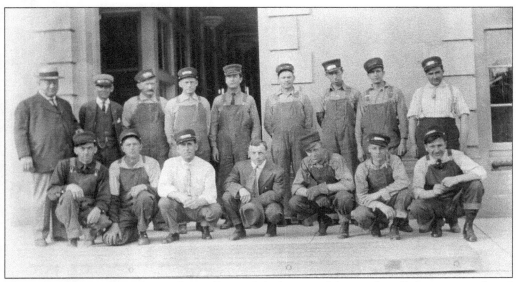

The numerous trains stopping at Pocatello needed a large workforce to handle baggage, mail, and express, as evidenced by this photograph of the station crew. The depot was open 24 hours a day for the numerous passenger trains that passed through, originated, and terminated at Pocatello.

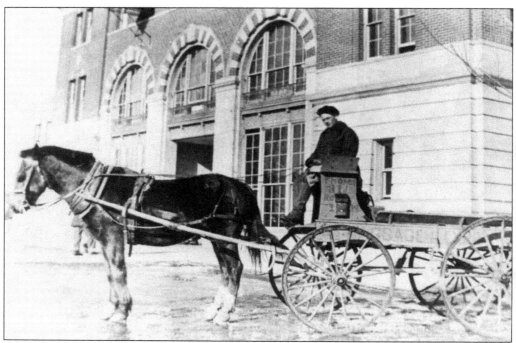

Horse-drawn wagons were used to deliver baggage and express from the station for many years. Cutler Hawkes poses in front of the depot on his wagon in this 1916 view.

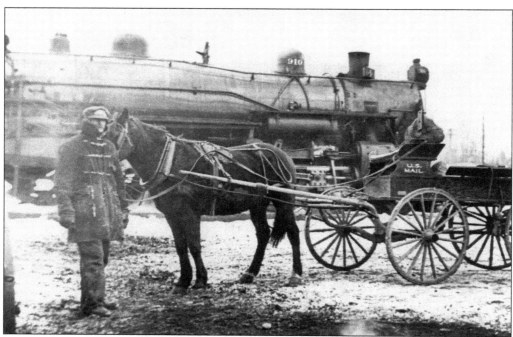

Mail arrived by train at the Pocatello depot. It is seen being picked up by George Hessell using this horse-drawn wagon. These wagons were used until they were replaced by motor-powered vehicles in the World War I period.

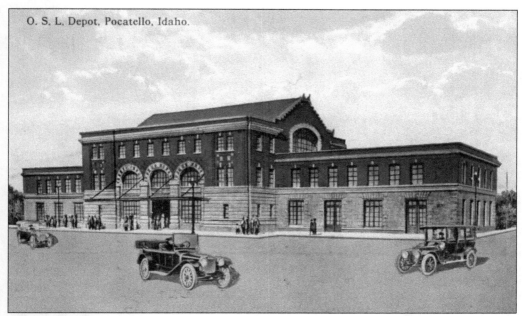

O. S. L. Depot, Pocatello, Idaho.

Made with some artistic license, this postcard shows the new Pocatello depot. The area in front of the building did not have a large, paved open area, and there was never a shelter over the main entrance. The artist also apparently did an early version of "Photoshopping" to put in bushes on the trackside of the building.

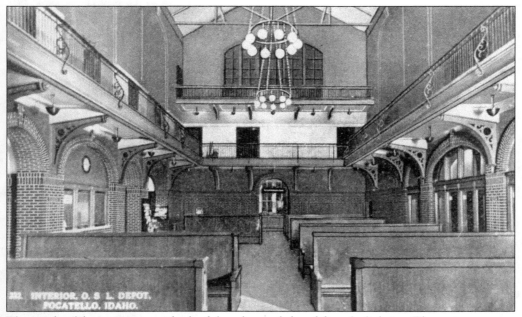

INTERIOR, O. S L. DEPOT, POCATELLO, IDAHO.

The inside of the waiting room had oak benches and chandeliers for lighting. The main entrance and restrooms are on the right, and the ticket office and exits to the tracks are on the left. The first floor of the interior of the depot has not been changed significantly, although the balcony has been replaced by a second floor. (John Aguirre collection.)

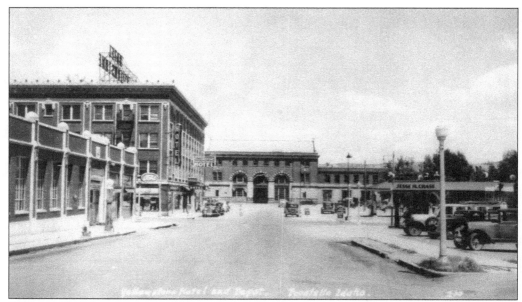

The Hotel Yellowstone was convenient to the recently opened Pocatello depot and was completed shortly after the station building was finished. When it was built, it was common to have a major hotel near the town's railroad depot so that arriving travelers could walk over to it for a night's rest.

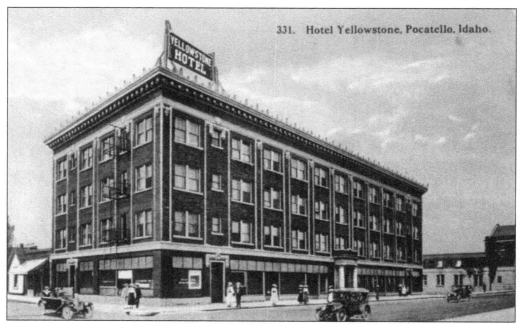

Based on the sign on the hotel roof, the new hotel was known as the Yellowstone Hotel, while the postcard says it was the Hotel Yellowstone. The depot can be seen on the right. The hotel was opened shortly after the new depot was completed in the downtown Pocatello business district. Salesmen could get off the train, walk over to the hotel from the depot, and sell their products from a showroom in the hotel. (John Aguirre collection.)

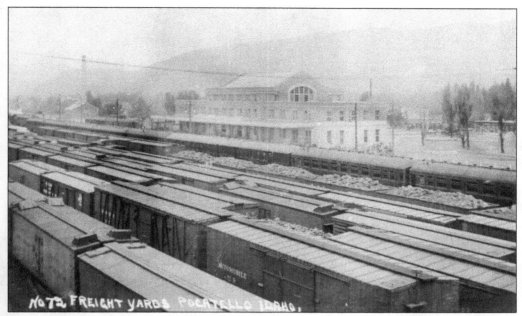

A view of the Pocatello depot taken from the Center Street viaduct shows the large number of freight cars that crowded the yard tracks. They include coal cars, a car used to carry automobiles, refrigerator cars, and passenger cars on the tracks in front of the depot. (John Aguirre collection.)

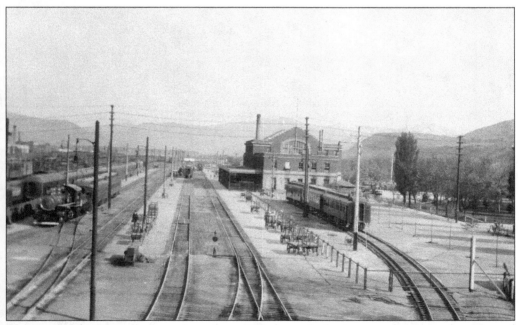

This view of the Pocatello depot from about 1924 shows the business track spur on the right and the station platforms with passenger cars on the tracks on the left in front of the depot. The large number of baggage carts was needed to transfer the mail, baggage, and express shipped on the trains.

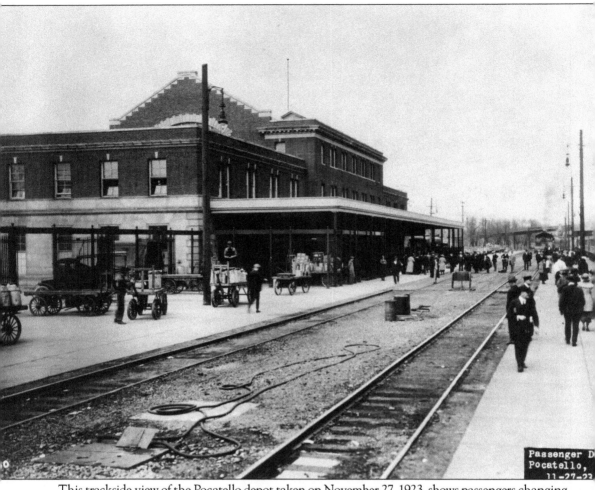

Passenger D
Pocatello,
11-27-23

This trackside view of the Pocatello depot taken on November 27, 1923, shows passengers changing trains. The gates on the side of the depot were used to control access to the tracks. There are numerous baggage carts used to handle the mail, express, baggage, and milk cans. A large-roofed enclosure over the platform in front of the depot was used to protect the waiting passengers from the weather. (Union Pacific Museum collection.)

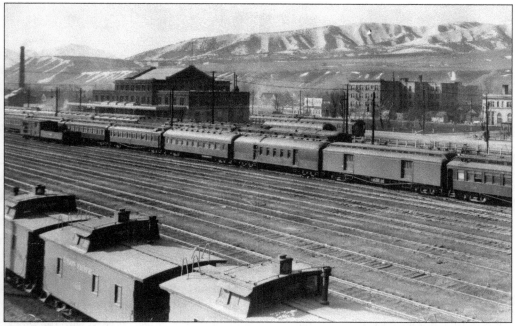

This view of the Pocatello depot from the Center Street viaduct shows a large number of passenger cars. Pocatello was a major junction with cars added, removed, and exchanged between passenger trains. The smokestack for the power plant used to provide steam to the depot is to the left of the station, and the downtown business district is on the right.

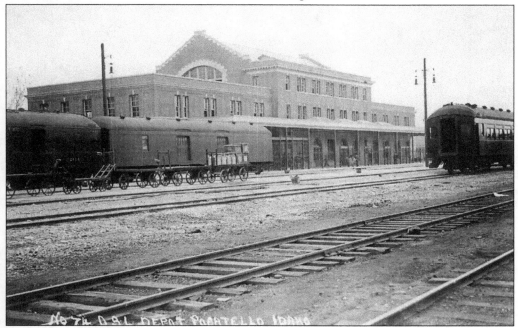

Pocatello once had a shelter over the platform next to the depot to protect the waiting passengers from the weather, and the track platforms were illuminated by the light fixtures on the tall poles. Milk cans are on the wagon next to the baggage car. (John Aguirre collection.)

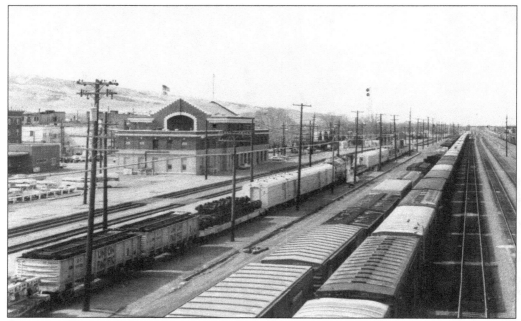

Taken in 1977, this is a view of the Pocatello depot from the Benton Street overpass with the wreck train spotted in the front of the depot, ready to go to the scene of the next accident. Although the depot is still standing, the wreck train is gone, and the railroad contracts out their cleanup work whenever there is a derailment today.

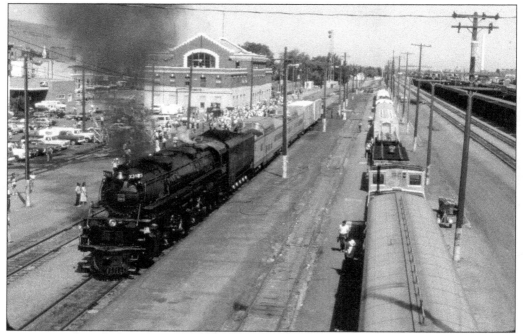

On June 27, 1982, the Union Pacific Railroad helped Pocatello celebrate the city's 100th anniversary by bringing in its steam locomotive No. 3985 for short excursion rides using cars from its fleet of refurbished passenger cars.

This view of the main entrance to the Pocatello depot was taken in 1977 from West Bonneville Street. The Amtrak insignia advertising the *Pioneer* passenger train is over the main entrance. The exterior of the building has not changed significantly over the years.

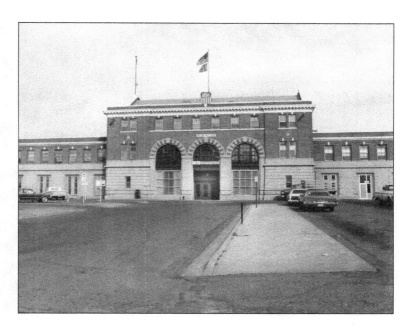

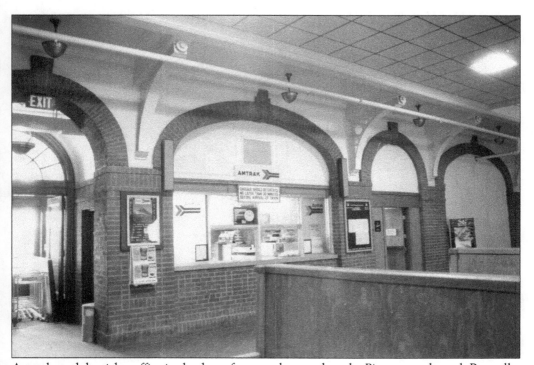

Amtrak used the ticket office in the depot for several years when the *Pioneer* ran through Pocatello. This picture was taken in 1989, shortly before the ticket office was closed. The *Pioneer* train ran from 1977 through 1997, stopping at Pocatello in the early hours of the morning.

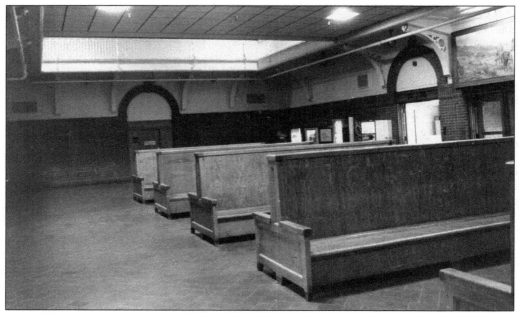

When this picture was taken in 1989, the oak benches in the waiting room were not being used by many passengers. The waiting room ceiling had been partially lowered to reduce the heating costs. A second floor has replaced the balcony today and the mural on the right has been moved to the Stephens Performing Arts Center on the Idaho State University campus.

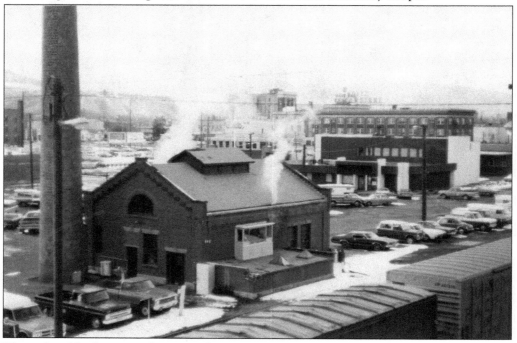

The railroad built a powerhouse to the east of the depot to provide steam to heat both the buildings and the passenger cars spotted in front of the depot. It was torn down in 1985 when it was no longer needed.

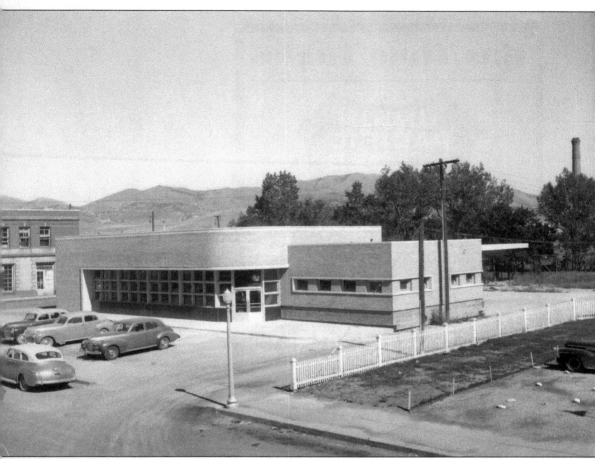

Prior to and immediately after World War II, the Union Pacific also operated a bus line, Union Pacific Stages, to replace the passenger trains on the lightly used branch lines and to supplement the mainline passenger trains. Seen in this photograph taken shortly after it was opened in 1946, the new Art Deco bus station was built on West Bonneville Street to replace a bus depot in a storefront in downtown Pocatello. The new building was convenient to the railroad depot, so travelers could easily transfer between the two modes of transportation. The railroad built a bus garage to the east, and it now houses a large model railroad layout built by the Pocatello Model Railroad & Historical Society. The bus depot has not been significantly altered over the years and still has the famous Greyhound running dog logo over the main entrance. The waiting room is on the left, the restrooms are on the right, and the bus bays are behind the building.

Bus Time Tables

UNION PACIFIC STAGES

CHICAGO AND NORTH WESTERN STAGES

Interstate Transit Lines

Chicago and

North Western
Stages

Union Pacific Stages
And Connecting Carriers

THE OVERLAND ROUTE
Coast to Coast

General Offices, OMAHA, NEBRASKA

Union Pacific Stages cooperated with the bus company owned by the Chicago and North Western Railway in promoting bus travel, as indicated by the cover of this timetable dated October 1, 1937. Union Pacific Stages was taken over by Greyhound in 1952.

In 1937, Union Pacific Stages ran buses between Salt Lake City and Butte/Edmonton, as seen in Table 113. It took almost six hours for the bus to run 170 miles between Salt Lake City and Pocatello, slightly longer than the passenger trains took.

SALT LAKE CITY—BUTTE—EDMONTON

NORTHB'D Read Down			Table 113		SOUTHB'D Read Up		
Daily	Daily	Daily			Daily	Daily	Daily
AM	PM	AM			PM	PM	AM
7.00	1.30	12.30	Lv Salt Lake City (A) Ar		9.30	2.20	6.00
8.10	2.40	1.40	" Ogden......Utah Ar		8.15	1.10	4.50
1.15	8.00	7.00	" Pocatello....Ida. Lv		3.30	8.40	12.25
3.00	9.45	8.40	Ar Idaho Falls (A) " Lv		1.30	7.00	10.30
3.15	10.45	9.40	Lv Idaho Falls(^). " Ar		12.50	6.30	10.10
7.22	2.57	1.47	Ar Dillon.......Ida. Lv		8.48	2.48	5.58
9.15	4.55	3.40	Ar Butte.......Mont. Lv		7.00	1.00	4.10
1.00	7.15	4.45	Lv Butte........." Ar		1.00	3.45
2.15	8.00	5.30	Ar Anaconda...." Lv		12.15	3.00
.....	11.20	8.57	" Missoula....." " "		9.00	11.40
.....	3.30	12.45	" Kalispell...." "		5.00	7.45
1.00	6.30	4.30	Lv Butte........." Ar		5.00	8.10	3.45
2.50	8.20	6.20	Ar Helena........" Lv		3.10	6 20	1.55
5.30	11.00	9.20	" Great Falls...." "		12.30	3.25	11.15
8.00	12.50	8.00	Lv Great Falls...." Ar		10.00	8.00
11.20	4.16	11.20	Ar Coutts (^)..Alb. Lv		6.00	4.30
12.45	12.45	Lv Coutts (E)....." Ar		6.40
3.00	3.00	Ar Lethbridge(E)." Lv		3.45
1.35	10.45	3.00	Lv Lethbridge(C)." Ar		12.45	4.05	7.40
2.45	11.50	Ar Macleod........" Lv		2.55	6.35
6.35	3.55	7.45	Ar Calgary........" Ar		8.00	11.05	2.30
7.00	4.30	11.30	Lv Calgary........" Ar		6.30	10.30	2.00
10.25	7.55	2.55	Ar Red Deer......" Lv		3.05	7.05	10.30
2.00	11.30	6.30	Ar Edmonton(C) Alb Lv		11.35	3.30	7.00

SALT LAKE CITY — POCATELLO — WEST YELLOWSTONE

NORTHBOUND Read Down					Table 11 Mountain Time	SOUTHBOUND Read Up				
Run 83	Run 89	Run 39	Run 85	Run 81		Run 80	Run 40	Run 84	Run 86	Run 88
	AM	PM	PM	AM		PM	PM	AM		AM
.....	12.30	7.30	1.30	7.00	Lv Salt Lake, Ut. Ar	2.20	5.00	9.30	6.00
.....	1.30	8.30	2.30	8.00	Ar Ogden..... " Lv	1.20	4.00	8.30	5.00
.....	1.40	8.45	2.40	8.10	Lv Ogden..... " Ar	R110	R350	8.15	4.50
.....	2.15	9.25	3.15	8.45	" Brigham.. " Lv	12.35	3.15	7.40	4.10
.....	2.55		3.55	9.25	" Wellsville. " "	11.56		7.00	3.30
.....	3.10		R410	R940	Ar Logan.... " "	11.42		6.50	3.15
.....	3.15		4.15	9.45	Lv Logan.... " Ar	R1132		M 620	R310
.....	3.25		4.27	9.55	" Smithfield. " Lv	11.22		6.10	2.59
.....	3.35		4.36	10.05	" Richmond. " "	11.12		6.00	2.48
.....	3.45		4.46	10.15	" Franklin.Ida. " "	11.02		5.50	2.37
.....	4.00		5.02	10.30	" Preston.. " "	10.50		5.40	2.25
.....	4.55		R600	R1125	Ar Downey... " Lv	9.50		4.45	1.30
.....		9.25			Lv Brigham..Ut. Ar		3.15	
.....		9.40			" Corinne.... " Lv		3.00	
.....		9.50			" Bear River, " "		2.50	
.....		10 00			" Tremonton, " "		2.37	
.....		10 05			" Garland... " "		2.32	
.....		10.13			" Riverside.. " "		2.27	
.....		10.23			" Plymouth.. " "		2.17	
.....		10.30			" Portage..Cor. " "		2.05	
.....		R1100			Ar Malad...Ida. " "		1.45	
.....		11.10			Lv Malad..... " Ar		1.45	
.....		11.50			Ar Downey... " Lv		1.10	
.....	4.55	11.50	6.10	11.30	Lv Downey.... " Ar	9.50	1.10	R440	1.30
.....	5.10	12.05	6.25	11.45	" Arimo..... " Lv	9.35	12.54	4.25	1.15
.....	5.20	12.15	6.37	11.55	" McCammon " "	9.25	12.44	4.15	1.05
PM	M605	R125	M725	M1240	Ar Pocatello.. " Lv	8.40	11.59	3.30	PM	12.25
5.30	7.00	1.05	8.00	1.15	Lv Pocatello.. " Ar	R830	M1125	R315	8.50	R1210
5.52	7.22	1.25	8.22	1.37	" Fort Hall.. " Lv	8.05	10.55	2.45	8.20	11.40
6.25	7.50	1.50	8.55	2.10	" Blackfoot.. " "	7.45	10.35	2.20	7.55	11.20
6.45	8.10	2.10	9.15	2.30	" Firth..... " "	7.25	10.15	2.00	7.35	11.00
6.55	8.20	2.20	9.25	2.40	" Shelley... " "	7.15	10.05	1.50	7.25	10.50
R715	8.40	2.35	9.45	3.00	Ar Idaho Falls " "	7.00	9.45	1.30	7.05	10.30
7.25	9.00	3.10	Lv Idaho Falls " Ar	R935	R110	R655
7.45	9.20	3.30	" Ucon..... " "	9.10	12.45	6.30
7.55	9.30	3.40	" Rigby..... " "	8.59	12.34	6.19
8.05	9.40	3.50	" Lorenzo.. " "	8.47	12.22	6.07
8.15	9.50	4.00	" Thornton.. " "	8.40	12.15	6.00
8.30	10.05	4.15	" Rexburg.. " "	8.30	12.05	5.50
8.40	10.15	4.25	" Sugar City, " "	8.22	11.57	5.42
8.55	10.25	4.40	Ar St. Anthony " "	8.10	11.45	5.30
8.55	Lv St. Anthony " Ar	8.10
F	" Chester... " Lv	F
9.20	" Ashton.... " "	7.45
.....	" Ponds.... " "
.....	No Service during Winter months			Ar Macks Inn. " Lv Lv Macks Inn. " Ar Ar West Yellowstone Mont. Lv	No Service during Winter months		

POCATELLO — BURLEY

Read Down		Table 12	Read Up			
Run 47	Run 45		Run 46	Run 48		
PM	AM	Mountain Time	AM	PM		
.....	4.00	7.00	Lv Pocatello..........Ida. Ar	10.15	5.15
.....	4.40	7.40	" American Falls........ " Lv	9.30	4.30
.....	F	F	" Yale.................. " "	F	F
.....	5.55	8.55	" Rupert.............. " "	8.15	3.15
.....	6.15	9.15	Ar Burley............Ida. Lv	8.00	3.00
	PM	AM		AM	PM	

(A) No local passenger service.

Table 11 of the 1937 timetable shows Union Pacific Stages also ran buses between Salt Lake City and Pocatello, Idaho Falls, and Ashton, and provided bus service to West Yellowstone in the summer months. The 51-mile trip between Idaho Falls and Pocatello took just over two hours, while most of the passenger trains were slightly faster. There was also bus service between Pocatello and Burley.

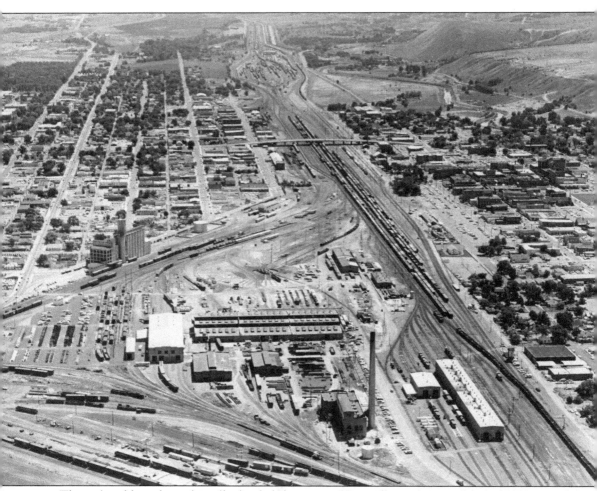

The railroad has always literally divided the town of Pocatello, as seen in this mid-1970s aerial photograph looking east. The large railroad shop complex is in the foreground. The downtown business district is on the right, and the industrial warehouses are on the left side of the tracks. Ross Park is the open green area to the left of the hump yard in the background.

Four

CROSSING THE TRACKS

Pocatello has always been literally divided by the railroad, with the business and residential districts on opposite sides of the tracks. For many years the only way to get from one side of town to the other was by walking across the tracks, a hazardous undertaking because of the numerous trains. Over the years, various bridges and underpasses (locally known as subways) were built. In 1911, a subway was opened under the tracks on Halliday Street, and a viaduct was built across the tracks at Center Street so that traffic would not have to cross the tracks at Lander Street and Center Street.

Driving over the Center Street bridge was a challenge because the east end of the bridge had two sharp, right-angle turns at the end so that the ramp down to the street level paralleled the tracks. This was done at the insistence of the local merchants who did not want a long ramp leading up to the bridge, believing it would block off their storefronts. When Pres. William Howard Taft, who was a large man, visited Pocatello in 1911 just after the Center Street viaduct opened, the original plans to drive him over the bridge reportedly had to be canceled because the large automobile needed to transport him could not make the sharp turns at the end of the bridge. Today, there are bridges over the tracks at Gould Street and Benton Street while there is a subway under the tracks at Center Street. The Center Street subway was built in 1934, and the Halliday Street subway was closed in 1966 when the Benton Street overpass was opened.

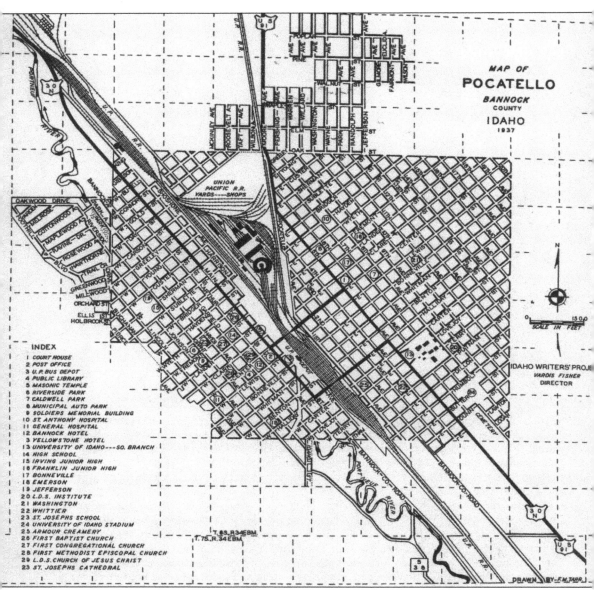

MAP OF POCATELLO
BANNOCK COUNTY
IDAHO
1937

UNION PACIFIC R.R. YARDS----SHOPS

IDAHO WRITERS' PROJECT
VARDIS FISHER
DIRECTOR

SCALE IN FEET
0 1500

INDEX
1 COURT HOUSE
2 POST OFFICE
3 U.P. BUS DEPOT
4 PUBLIC LIBRARY
5 MASONIC TEMPLE
6 RIVERSIDE PARK
7 CALDWELL PARK
8 MUNICIPAL AUTO PARK
9 SOLDIERS MEMORIAL BUILDING
10 ST. ANTHONY HOSPITAL
11 GENERAL HOSPITAL
12 BANNOCK HOTEL
13 YELLOWSTONE HOTEL
13 UNIVERSITY OF IDAHO---SO. BRANCH
14 HIGH SCHOOL
15 IRVING JUNIOR HIGH
16 FRANKLIN JUNIOR HIGH
17 BONNEVILLE
18 EMERSON
19 JEFFERSON
20 L.D.S. INSTITUTE
21 WASHINGTON
22 WHITTIER
23 ST. JOSEPHS SCHOOL
24 UNIVERSITY OF IDAHO STADIUM
25 ARMOUR CREAMERY
26 FIRST BAPTIST CHURCH
27 FIRST CONGREGATIONAL CHURCH
28 FIRST METHODIST EPISCOPAL CHURCH
29 L.D.S. CHURCH OF JESUS CHRIST
23 ST. JOSEPHS CATHEDRAL

DRAWN BY F.M.TARR

This map of Pocatello in 1937 shows how the railroad divided the town. At this time, there were subways under the tracks at both Center and Halliday Streets. The Center Street subway is still in use while the Halliday Street subway was replaced by the Benton Street overpass. (*The Idaho Encyclopedia,* WPA.)

Prior to the subways and viaducts, Pocatello residents had to walk across the tracks. Lander and Center Streets were popular locations to cross the tracks since the streets were near the depot. This view shows travelers of all ages crossing the tracks at Lander Street. This was a dangerous undertaking because there were numerous trains continuously moving back and forth at all hours.

The Center Street viaduct was built in 1911, requiring the east end of the Pacific Hotel to be torn down, as seen in this photograph. The viaduct piers are being built using horse-drawn equipment while the locals are crossing the tracks on a well-traveled path.

The girders for the Center Street viaduct are being raised over the tracks, almost hiding the Pacific Hotel. They were manufactured by the American Bridge Company, a supplier of bridges for railroads across the country.

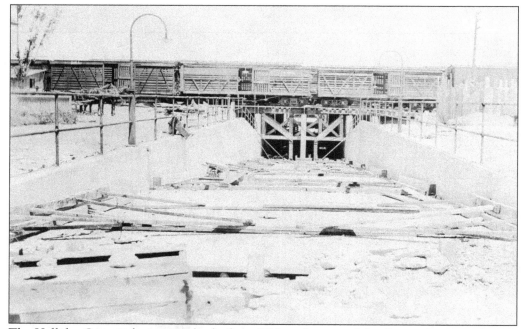

The Halliday Street subway was also built in 1911 to the east of the Center Street viaduct. It was a two-lane road built directly under the tracks and was used until 1966 when the Benton Street overpass was built. Constructing the underpass under the tracks while they were in service required special bracing.

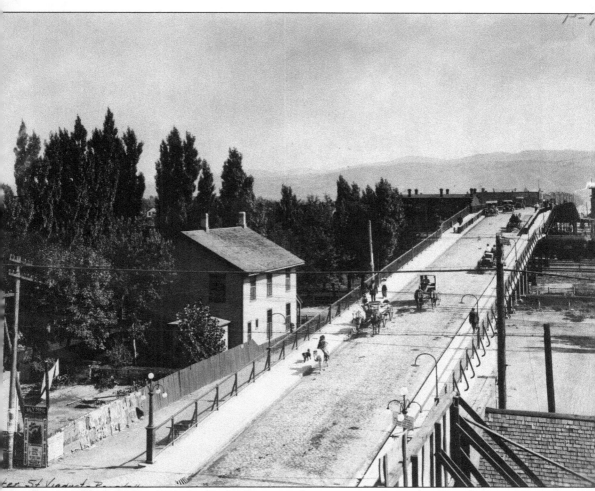

After it was opened in 1911, the Center Street viaduct was a popular and well-used route across the railroad tracks. It was also much safer because pedestrians and vehicles did not have to dodge the trains. A wide variety of transportation was being used when this picture was taken, ranging from the Indian on horseback with a dog to the horse-drawn carriages, to the new automobiles. The poster in the left-hand corner of this view is advertising the movie at the Olympic Theatre, which had a pipe organ. (Union Pacific Museum collection.)

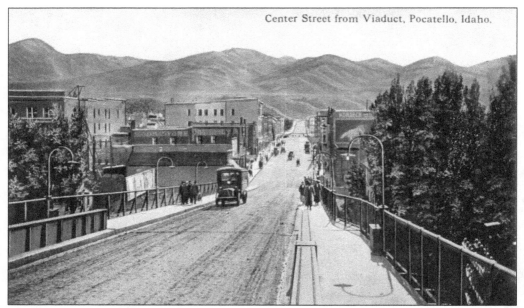

Center Street from Viaduct, Pocatello, Idaho.

This is a postcard view showing Pocatello from the Center Street viaduct with a Pocatello Streetcar Company bus going up the steep grade to cross the railroad tracks. Although there were once plans for a streetcar line in Pocatello, it was never built because of local opposition.

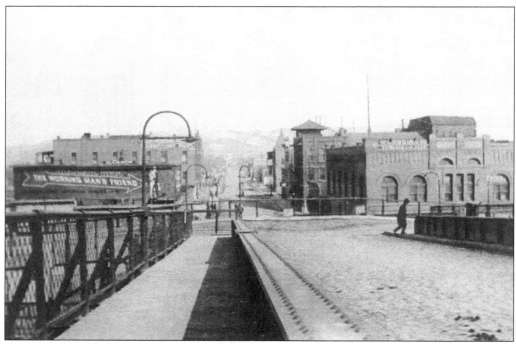

The east end of the Center Street viaduct had two sharp turns, making it difficult to maneuver. The ramps were built parallel to the tracks at the insistence of the local businessmen, who did not want their businesses blocked by the ramp up to the bridge. The roadways to the bridge can be seen coming up on the left and descending on the right.

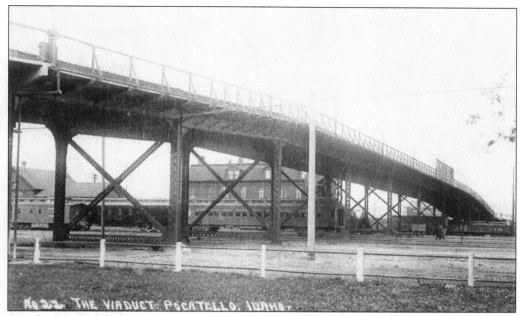

Another view of the Center Street viaduct shows the Pacific Hotel in the background. Despite the construction of the Center Street viaduct, pedestrians were still using a path to walk across the tracks, as indicated by the pathway under the viaduct and across the tracks.

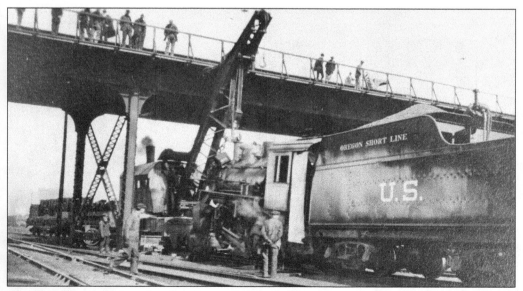

Not all trains made it under the Center Street viaduct, as seen in this March 21, 1919, view showing a locomotive being re-railed after it left the tracks. The viaduct provided a good location for the locals to watch the work.

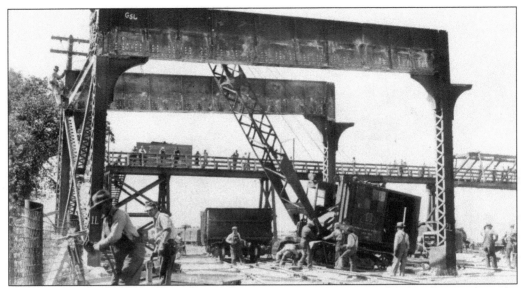

After the Center Street subway was built in 1934, the viaduct was immediately torn down by Morrison Knudsen. A temporary wood walkway was built next to the viaduct, which provided an observation point for the locals to survey the work.

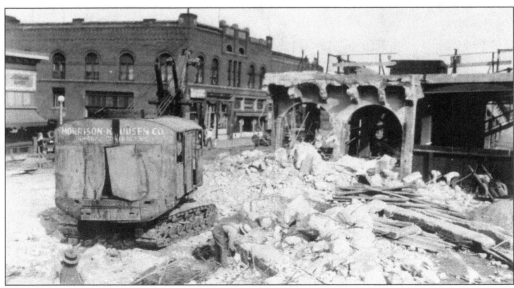

The Center Street viaduct was not missed when it was razed, especially the east end with the sharp turns. City offices were once under the viaduct ramps.

Five

PASSENGER TRAINS

Until the advent of the automobile and improved roads, most travel over long distances—and even short distances—was on passenger trains. Consequently, the railroad depot was the center of activity in Pocatello with travelers arriving and departing on passenger trains 24 hours a day in all directions of the compass. Baggage, mail, and express were also shipped on these trains.

The names of trains passing through Pocatello included the *Portland Rose* and the *City of Portland*, which ran between Chicago and Portland; the *Butte Special* and the *Butte Express*, which ran between Salt Lake City and Butte; and the summertime-only *Yellowstone Special* and *Yellowstone Express*, which ran between Salt Lake City and West Yellowstone at the west entrance to Yellowstone National Park. Some of these trains passed through Pocatello in the middle of the night. There were also numerous local trains that ran out of Pocatello south to Ogden and Salt Lake City, west to Buhl, and north to Idaho Falls, Ashton, and Victor. Connecting train service allowed travel to other towns in southern Idaho. Passenger cars were exchanged between trains at Pocatello so that through-coach and sleeping-car service was possible between destinations such as Chicago and West Yellowstone and Salt Lake City and Buhl.

The passenger trains were gradually discontinued after World War II, and all passenger service through Pocatello was discontinued on May 1, 1971, when Amtrak took over the nation's passenger rail service. By that time, the only passenger trains running through Pocatello were the daily *City of Portland* and *Portland Rose* trains and the triweekly *Butte Special* train. Amtrak experimented with the *Pioneer* running through Pocatello, providing service to Chicago, Portland, and Seattle, beginning the train service in 1977 and ending it in 1997. Since then there have only been occasional special passenger trains that have operated through Pocatello. By custom, the railroad used odd numbers for trains going west, away from the Omaha headquarters, and even numbers for trains going east. Trains going north to Montana were considered to be headed west and had odd numbers while their counterpart southbound trains were considered to be headed east, so they had even numbers.

OREGON SHORT LINE RAILROAD.

E. H. HARRIMAN, President, 120 Broadway, New York.
W. D. CORNISH, Vice-President, "
W. H. BANCROFT, Vice-Prest. & Gen. Mgr., Salt Lake City, Utah.
WINSLOW S. PIERCE, General Counsel, 120Broadway, New York.
ALEX. MILLAR, Secretary, "
FREDERIC V. S. CROSBY, Treasurer, Omaha, Neb.
J. B. BERRY, Consulting Engineer, "
P. L. WILLIAMS, General Attorney, Salt Lake City, Utah.
S. W. ECCLES, General Traffic Manager, "
E. E. CALVIN, General Supt. and Supt. Telegraph, "
F. W. HILLS, Auditor, "
A. J. VAN KURAN, Local Treasurer, "
D. E. BURLEY, General Passenger and Ticket Agent, "
J. A. REEVES, Assistant General Freight Agent, "

S. H. PINKERTON, Chief Surgeon, Salt Lake City, Utah.
J. F. DUNN, Superintendent Motive Power, "
WM. ASHTON, Resident Engineer, "
I. O. RHOADES, General Purchasing Agent, "
G. L. HICKEY, Car Accountant, "
GEO. LAALLEY, General Baggage Agent, "
J. B. EVANS, Tax Agent, "
E. J. FISHER, General Claim Agent, Pocatello, Idaho.
E. O. MANSON, Superintendent Idaho Division, "
L. MALLOY, Acting Superintendent Montana Division, "
J. H. YOUNG, Superintendent Utah Division, Salt Lake City, Utah.
W. E. COMAN, General Agent, 201 Main St., "
H. O. WILSON, General Agent, 105 North Main St., Butte, Mont.
D. W. HITCHCOCK, Gen. Agt., No. 1 Montgomery St., San Francisco, Cal.

[The remainder of this page consists of extremely dense railroad timetable tables with numerous station listings, times, and elevations that are not reliably legible for faithful transcription.]

Line Ogden to Salt Lake City.

Nampa to Boise City.

Line Salt Lake City to Frisco.

Line Salt Lake City and Ogden to Butte and Helena.

Additional Train—Leaves Nampa *9 30 a.m., arriving Huntington 4 45 p.m. Leaves Huntington *7 00 a.m., arriving Nampa 2 30 p.m.

Line Lehi Junction to Silver City and Eureka.

Line Shoshone to Ketchum.

Line Cache Junction to Preston.

21*

As shown in this timetable, in 1900 the Oregon Short Line ran two trains a day through Pocatello between Granger, Wyoming, and Portland/Seattle, and two trains a day between Salt Lake City and Butte. Additional passenger trains were added to the schedule as the railroad built branch lines in southern Idaho in the years before World War I.

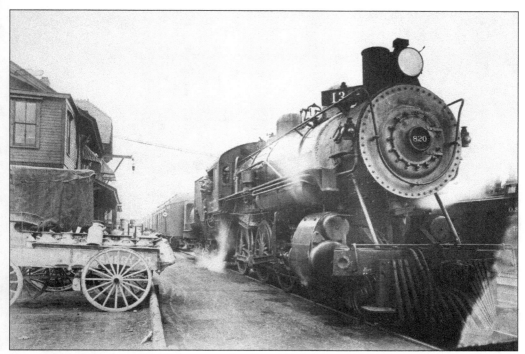

Oregon Short Line train No. 13 has arrived at Pocatello on its way from Salt Lake City to Butte in the early 1900s. The engineer and fireman are looking at the photographer from the locomotive cab. The milk cans on the wagon were being shipped by train.

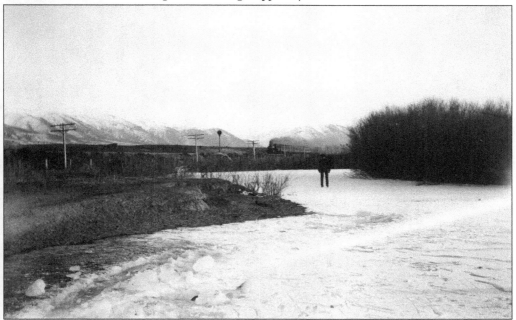

A westbound train is seen arriving at Pocatello about 1902. It is winter, and the man is skating on the Portneuf River as he observes the arriving train. Passenger trains were the only feasible way to travel long distances in the winter months when the roads were blocked by snow.

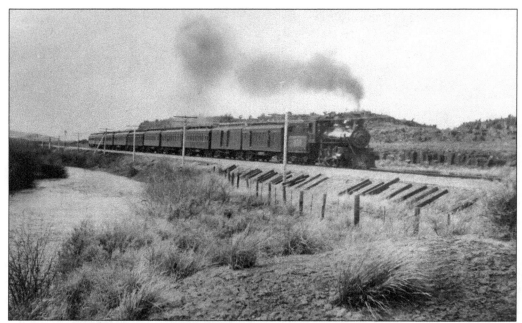

It is about 1902, and this long eastbound passenger train has just left Pocatello. The 10-car train has a railway post office car on the front, followed by a baggage car and eight passenger cars. The Portneuf River is on the left, and new railroad ties have been placed along the tracks, ready for the section crew to insert them under the rails.

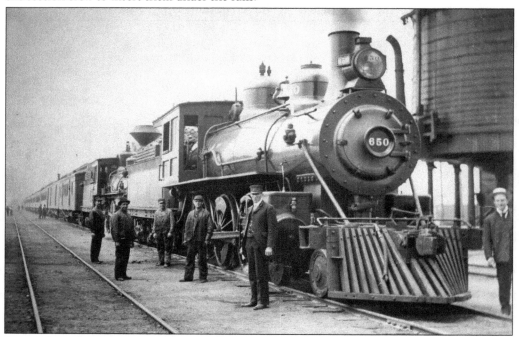

An eastbound passenger train long enough that it has to be pulled by two steam locomotives is at Pocatello around the year 1905. A railway post office car is behind the second locomotive, followed by a baggage car and a long string of coaches.

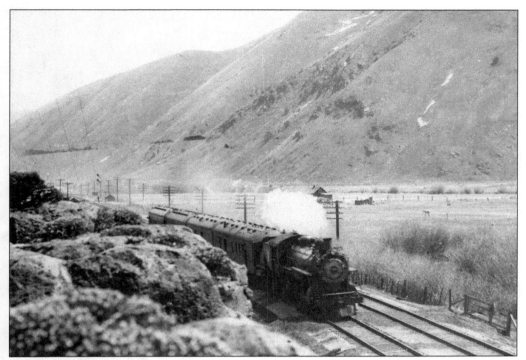

A short westbound four-car passenger train consisting of a railway post office car, a baggage car, and two coaches is passing through the Portneuf Gap and approaching Pocatello. This train consist was typical for most local trains.

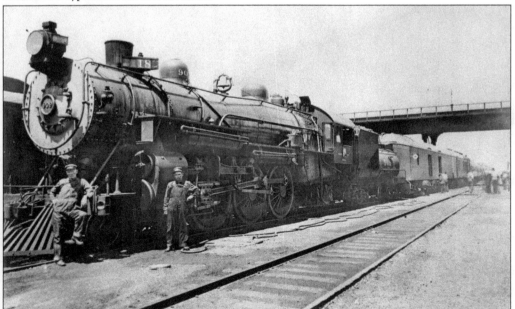

It is just before World War I, and train No. 18, the eastbound *Oregon-Washington Limited*, has stopped at the Pocatello depot to be serviced and to exchange passengers, baggage, mail, and express. The long, heavy passenger trains required large steam locomotives such as this one.

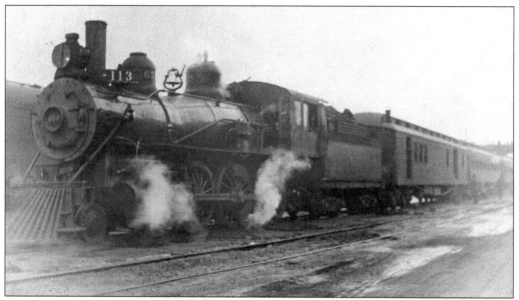

Train No. 113 is seen at Pocatello, probably in the first decade of the 20th century. This train is the Salt Lake City–St. Anthony local with a combination railway post office/baggage car on the front end followed by standard passenger coaches.

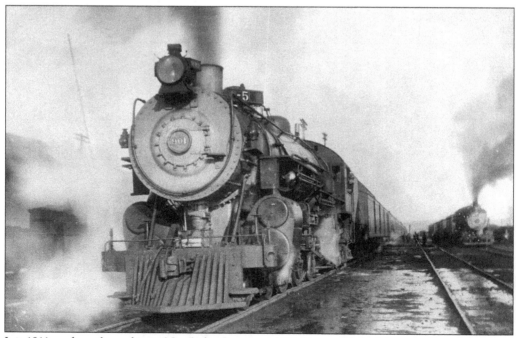

It is 1911, and westbound train No. 5, the *Oregon and Washington Limited*, is at the Pocatello depot. A freight train can be seen on the right. The steam, smoke, and cinders from the locomotives were considered to be signs of prosperity by many Pocatello residents, although it did tend to dirty the wash drying outside on clotheslines.

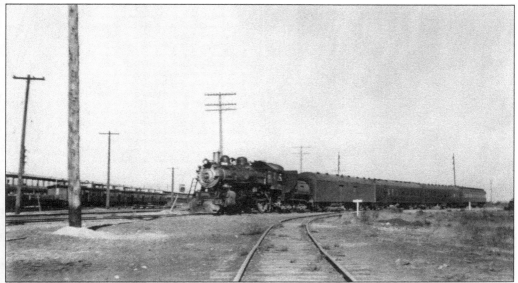

Train No. 556, the Ashton–Salt Lake City local, is seen arriving at Pocatello from the north around 1940 with a baggage car and three coaches. This was a typical local train of the era. The icing docks, used to add ice to the refrigerator cars, can be seen in the background to the left of the train.

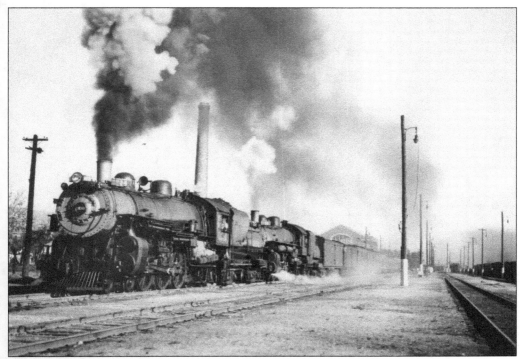

It is July 4, 1936, and eastbound train No. 14, the *Pacific Limited*, is leaving the Pocatello depot headed for Chicago. Despite the Depression, the heavy holiday traffic required two steam locomotives to pull the long train.

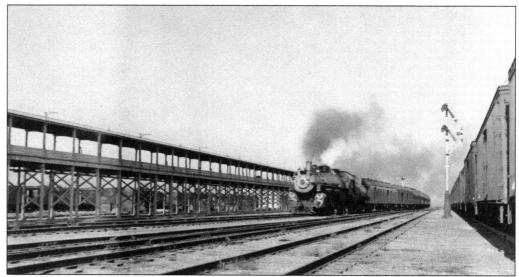

It is about 1932, and train No. 20, the eastbound train *Pacific Limited*, is passing the icing docks just before it arrives at the Pocatello station. The Depression caused a dramatic drop in passengers who traveled by train, followed by a surge in traffic during World War II. After the war, there was a steeper, permanent decline in passenger traffic and with that, the discontinuance of all passenger trains through Pocatello in 1971.

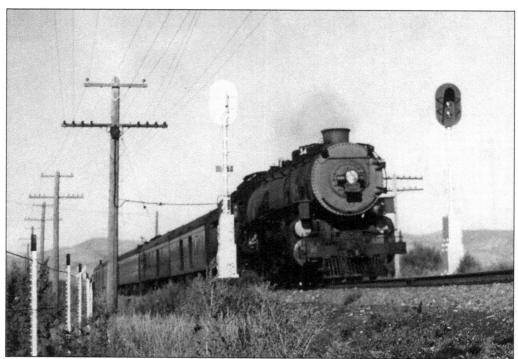

It is about 1950, and eastbound train No. 34, the *Northwest Special* from Victor to Salt Lake City, is arriving at Pocatello. The train was used by tourists going to Yellowstone and Grand Teton National Parks. This train provided connecting service to Los Angeles.

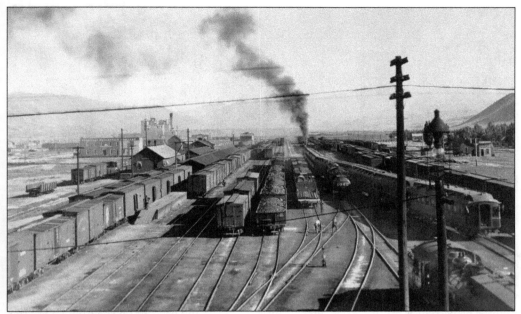

A long eastbound train is seen leaving east from Pocatello toward the Portneuf Gap. Pocatello has always been an important, busy railroad junction, as evidenced by the tracks crowded with freight and passenger cars.

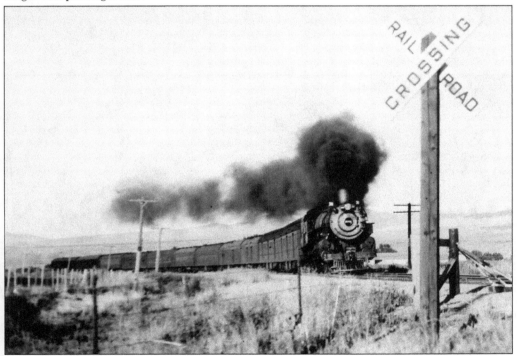

A train is seen at Pocatello Junction arriving from the north about 1946 with a large number of baggage and mail cars on the front end. The mail and express business provided valuable revenue to the railroad.

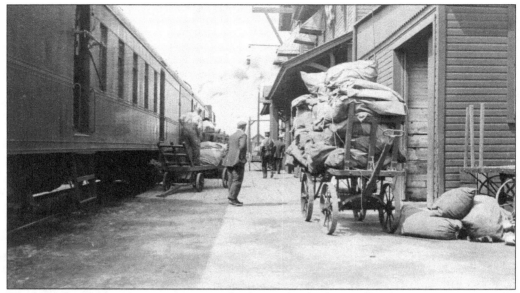

Westbound mail train No. 5 is seen in 1911 loading and unloading mail and express at the Pocatello depot. The passenger trains carried large quantities of mail and baggage on the front end of the trains. The Railway Express Agency, the equivalent of today's United Parcel Service and Federal Express, used the trains to ship packages.

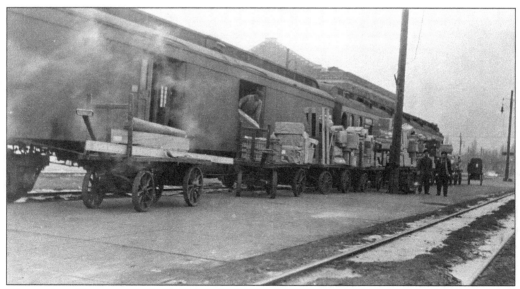

The mail and baggage is piled high on the baggage wagons in front of the Pocatello depot. The railroads provided an essential means of transportation for the mail and express, especially in the winter months when the roads were closed by the heavy snowfalls.

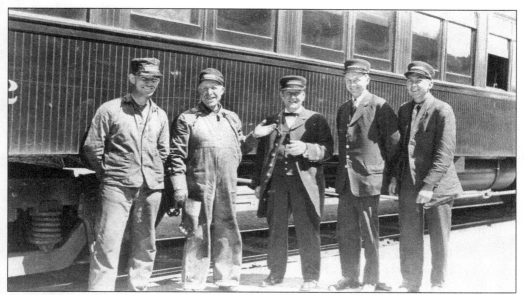

Passenger trains had large crews, including the engineer, fireman, conductor, and brakemen. These were prestigious positions that provided good-paying, reliable jobs. These men are obviously enjoying posing for the photographer.

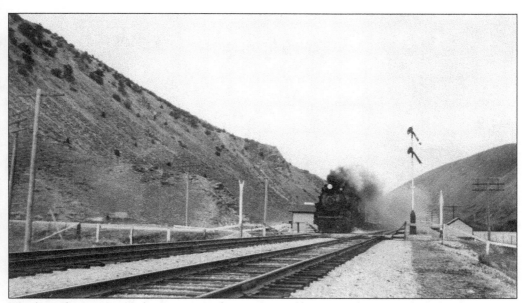

Westbound train No. 17, the *Oregon-Washington Limited* between Chicago and Portland, is passing through the Portneuf Gap just before reaching Pocatello sometime in 1923. Semaphore signals, such as the ones on the right-hand track, were used to control the train operations.

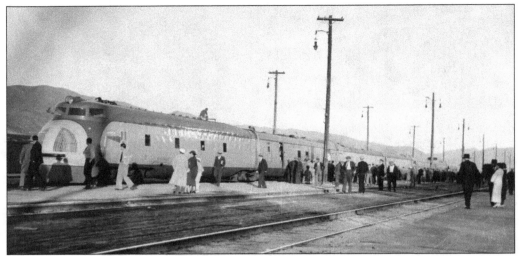

The M10001, the *City of Portland,* was the second streamlined passenger train introduced by the Union Pacific, and it ran between Chicago and Portland. It is seen in 1935 at Pocatello on one of its first trips, being inspected by local residents and the passengers on the train. The new streamlined trains resulted in a large increase in passenger traffic because the accommodations were better and the trains faster.

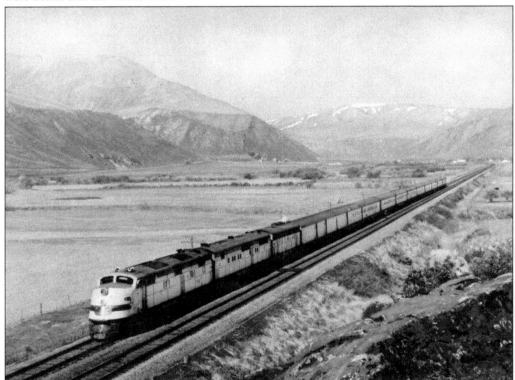

The Union Pacific had advertisements showing its new streamlined passenger trains at Pocatello. The *City of Portland* has passed through the Portneuf Gap and is approaching Pocatello. This painting was used on one railroad's well-known calendars. (Union Pacific Museum collection.)

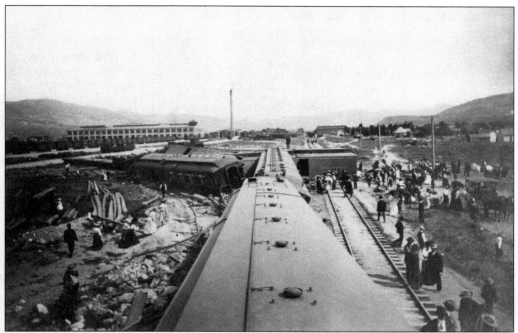

Unfortunately, sometimes there were train accidents. In June 1903, an eastbound passenger train left the track just before arriving at Pocatello, killing the fireman and injuring several train employees. Train accidents such as this one always generated large crowds of sightseers.

Railroad employees were required to have watches that kept accurate time because the trains' operations were based on precise schedules. Jewelers often advertised that they were official watch inspectors for the railroad, as seen in this advertisement by G.G. Voege in Pocatello. (John Aguirre collection.)

By 1970, there were only three passenger trains that ran through Pocatello: the daily *City of Portland* and the *Portland Rose* (schedule 20) and the tri-weekly *Butte Special* (schedule 36), as shown on these schedules taken from one of the railroad's last timetables. Although the Union Pacific Railroad maintained the quality of its passenger service, travelers deserted the trains for the convenience of their own automobile and the speed of the airplane, and all passenger service was discontinued on May 1, 1971.

Six

FREIGHT TRAINS

Although passenger trains were the most visible and public aspect of the railroad operations, freight trains provided most of the business and revenue on the railroad. Freight trains arrived and departed Pocatello in all four directions of the compass 24 hours a day. The trains had to be inspected, sorted, and made up into new trains. In addition, the steam locomotives were switched and serviced, and the train crews changed at Pocatello.

To receive and sort the hundreds of freight cars that came in each day, the railroad had a large train yard. Because Pocatello was such an important junction, the railroad spent $2.6 million at the end of World War II to build a new gravity switching yard to sort the cars into the different trains. The cars were pushed up to the top of a small hill called a hump and rolled down the other side. Retarders slowed the cars as they went down the hill with the switches remotely controlled to direct the cars onto the appropriate track. The new yard included 35 miles of track, 14 receiving tracks, a 28-track classification yard later expanded to 40 tracks, and an 11-track departure yard. Opened in October 1947, it was the first Union Pacific yard to use retarders. The retarders that kept the freight cars from going too fast down the hill worked by clamping down onto the car wheels, making a squealing noise that could be heard all over the city.

The hump yard was busy until the 1990s when the 40-track yard was reduced back to 28 tracks. With the advent of unit trains and trailer and container traffic and the decline in single-car traffic, there was a reduced need for the switching facilities. The hump was closed in March 2002 and the yard tracks removed. The hump was removed in the fall of 2011. Receiving and departure tracks are now used for sorting out the traffic that needs to be switched between trains.

RAILROAD
MAGAZINE

December 15¢ Canada 17¢

Pocatello Yardmaster *by* HARRY McCLINTOCK

Pocatello gained notoriety for the nonexistent railroad position of Pocatello night yardmaster. The history of the title is obscure, as many legends are, but the December 1940 issue of *Railroad Magazine* had an article written by Harry McClintock giving the background of the story. McClintock believes the story dates back to a nationwide railroad strike that took place in 1894. After the strike, there were many railroaders who needed letters of recommendation to repair their tarnished record. The superintendent's chief clerk at Pocatello wanted to increase his small salary, and he hit on the idea of selling letters of commendation from his office at $5 a copy. A boomer, which is a railroader who worked on railroads all over the country, would gladly pay the money for a letter stating he had been night yardmaster at Pocatello. It did not take long for the boomers to stop by to get a letter to restore their credentials. Obviously, some of the more inept and incompetent railroaders were among those who got the letter, and the term was accepted to be someone who was a "loud-mouthed incompetent, a know-it-all, a guy who 'talks' a darn good job of railroading, but fails to deliver in the pinches."

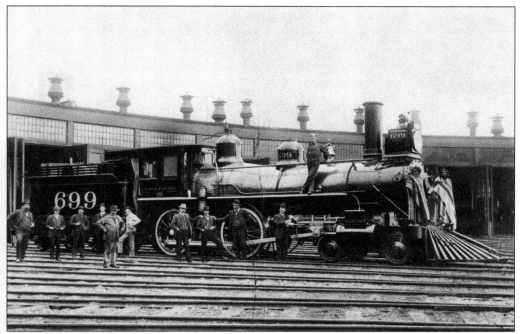

It is 1889, and the train crew, railroad officials, and some Indians have posed with the Union Pacific locomotive No. 699 for the photographer in front of the Pocatello roundhouse. The 4-4-0 locomotive was the standard motive power used at this time.

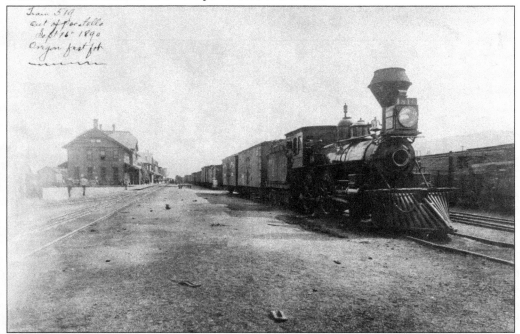

The Oregon Fast Freight is in front of the Pocatello depot, ready to head west to Portland in this view taken on September 16, 1890. The first two cars have been cut off from the rest of the train to allow the foot traffic across the tracks.

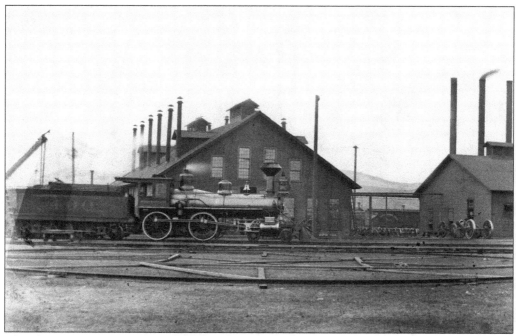

This classic 4-4-0 Oregon Short Line locomotive was typical of the motive power at the beginning of the 20th century. It was photographed in front of the Pocatello shop buildings in 1903. Many of the shop buildings were wood, despite the obvious fire danger caused by the presence of the steam locomotives, which exhausted hot cinders out their smokestacks.

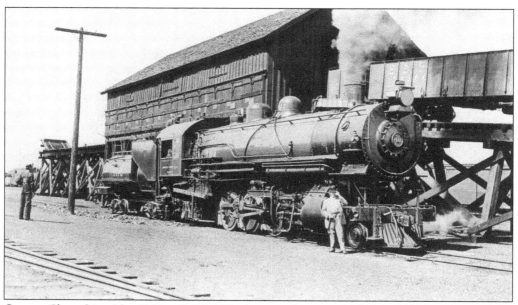

Oregon Short Line No. 1112, a 2-8-2 Mikado, was photographed about 1910 in front of the Pocatello coaling dock. Carloads of coal were pushed up the incline and the coal dumped into bins so that it could then be used to fill the steam locomotive tenders.

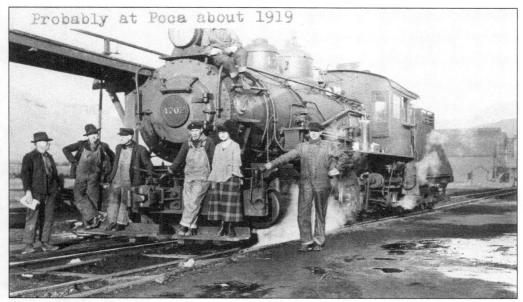

Probably at Poca about 1919

The local switching crew has posed in front of their locomotive at Pocatello around the year 1919. It must have been a special occasion, as the wife or girlfriend of one of the crewmen is standing on the front of the engine.

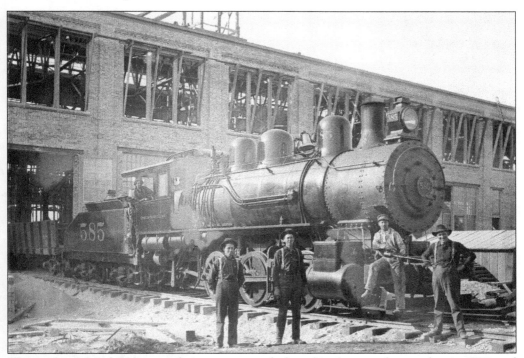

The machine shop building was being constructed when this photograph was taken in 1902, and Oregon Short Line No. 585 is being used to haul some of the construction materials. Of note is the long-handled oilcan, an essential item for the engineer and fireman, being held by the fireman resting on the front of the locomotive.

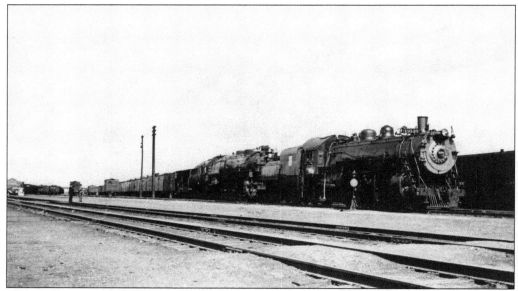

These two steam locomotives are leaving Pocatello for the east pulling a long string of refrigerator cars in March 1933. Ice was added to refrigerator cars at Pocatello to help keep the car contents cold, and heaters were added in the winter months to keep the car contents from freezing.

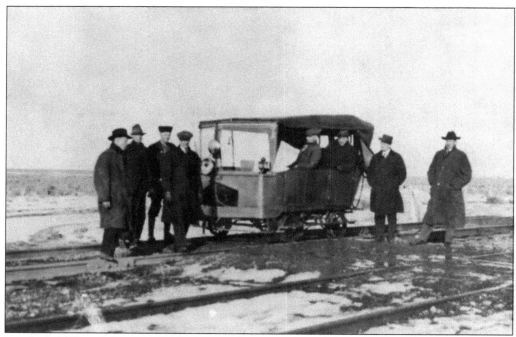

It is about 1919, and this is one of the first gasoline motorcars at Pocatello. Section crews and officials used these cars to inspect and maintain the tracks. Prior to the use of these cars, the men had to provide the motive power for the section cars by manually pumping handles up and down.

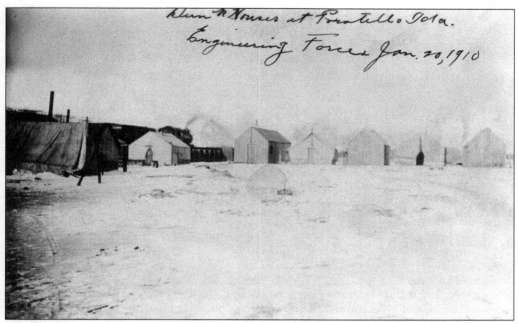

Alun & Houses at Pocatello, Ida.
Engineering Force Jan. 20, 1910

In 1910, the Oregon Short Line added a second track on the line from Pocatello east to McCammon because of the large number of trains going to and from Utah and Wyoming. Although the work was being done during the winter, the workforces lived in these tents. (Union Pacific Museum collection.)

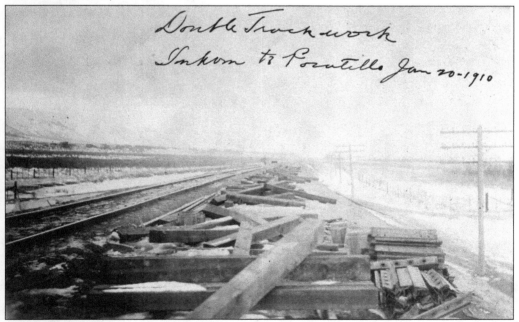

Double Track work
Inkom to Pocatello Jan 20-1910

This is another view of the work to add the second track near Inkom between Pocatello and McCammon. Large quantities of rail, ties, spikes, tie plates, and other materials were required to build the second track. The engineering group took frequent photographs to show the work progress. (Union Pacific Museum collection.)

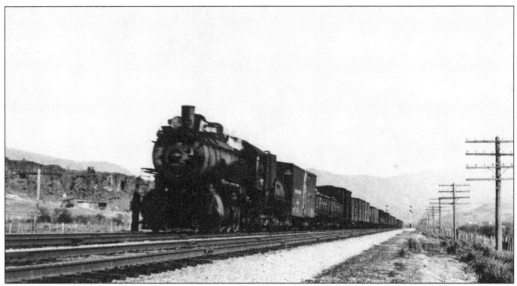

A westbound freight train is seen approaching Pocatello in 1928 on the double-track main line between Pocatello and McCammon. This section of line was busy with passenger and freight trains and sees numerous freight trains today.

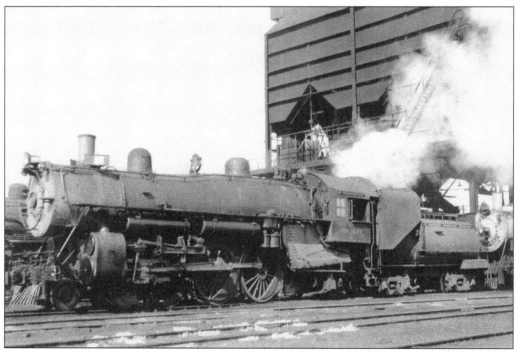

As the years passed, the steam locomotives got bigger and heavier. This is a 4-6-2 Pacific locomotive at the 900-ton Pocatello coaling tower on March 10, 1935. The locomotive was built in 1912 by the Schenectady division of ALCO.

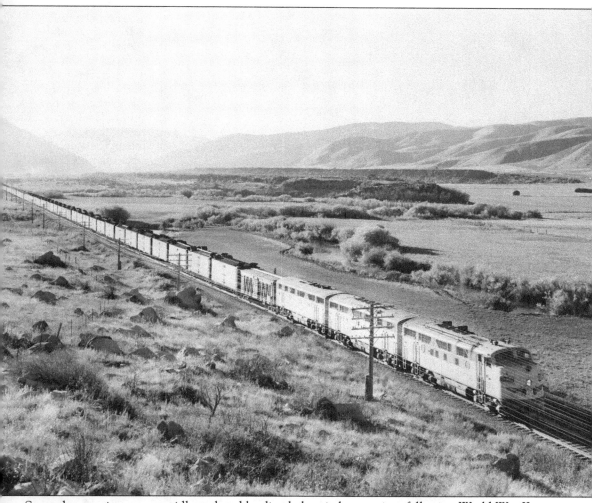

Steam locomotives were rapidly replaced by diesel-electric locomotives following World War II. A westbound string of empty refrigerator cars is approaching Pocatello, pulled by three diesel-electric locomotives. The hatches on the top of the ice-cooled refrigerator cars are opened to allow the car to dry out before being loaded with another shipment of fresh produce. Portneuf Creek is to the right of the tracks, and the Portneuf Gap is in the background. (Union Pacific Museum collection.)

The new gravity switching yard in Pocatello was opened in October 1947. The retarders seen in the foreground slowed the cars as they rolled down from the top of the hump by clamping onto the wheel rims. The receiving tracks were built on the former flat switching yard, and the new yard extended three and a half miles east from the depot. (Union Pacific Museum collection.)

The cars being sorted were slowly pushed up to the top of the hump, where a "pin-puller" uncoupled the cars. After the cars were uncoupled, they rolled down the hill. The operator in the tower would actuate switches so the car would go onto the proper track and power the retarders to slow down the car. This view taken from the hump tower shows the cars being distributed on the various tracks. The yard was closed in 2002. (Photograph taken by Thornton Waite.)

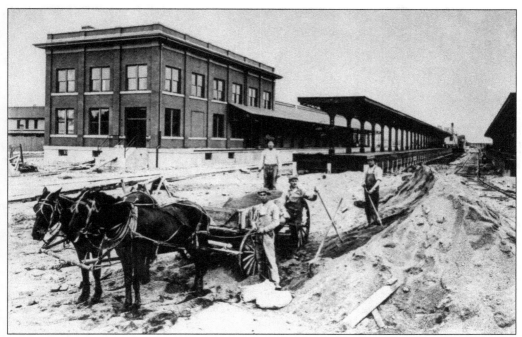

Pocatello had a freight house across the tracks from the depot, shown being built about 1913. The two-story brick head building was used for the offices, and the platforms were used to load and unload freight cars. Horse-drawn wagons and manual labor were used for the construction work.

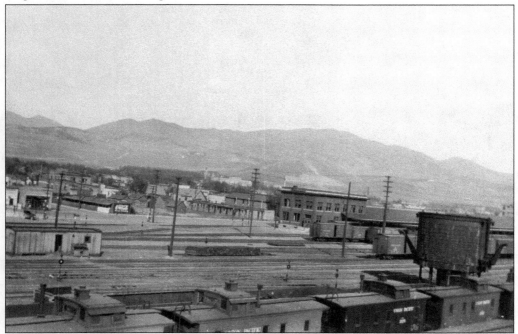

This view of the freight house was taken from the depot. A water tank used to provide the water to the steam locomotives is on the right behind the caboose track. An old boxcar seen on the left is a shelter for the train crews.

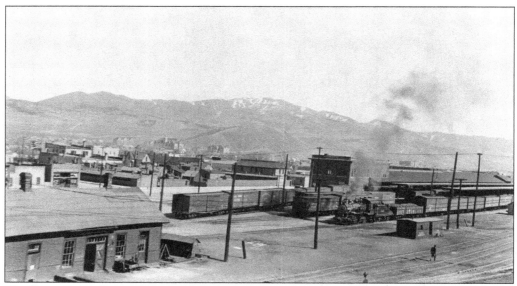

The Pocatello yards were busy with local switching activities as well as the freight and passenger trains. A switcher is shuffling some cars at the freight house in 1914. Small quantities of freight were loaded into and unloaded from boxcars there.

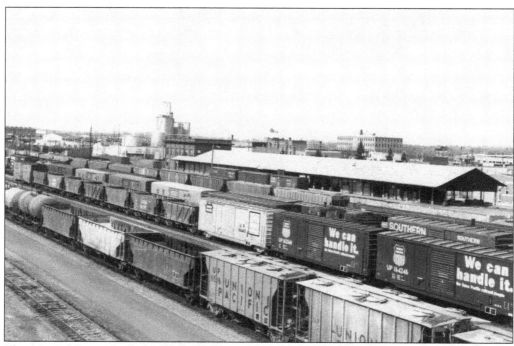

This view of the trackside of the freight house was taken in 1977, shortly before it was torn down. The freight house had an enclosed area on the left as well as an open dock on the right side. The freight once handled in the freight house is now typically transported by highway trucks. (Photograph taken by Thornton Waite.)

Seven

THE POCATELLO SHOPS

Because Pocatello was a major rail junction, the railroad built large shops to repair, maintain, and build equipment. In the late 1880s, they moved the shops from Eagle Rock (present-day Idaho Falls) and Shoshone, consolidating them at Pocatello. This created a serious problem because Pocatello was on the Fort Hall Indian Reservation, and the railroad buildings were restricted to a narrow strip of land, meaning there was not enough space for the shops and houses for the employees. It was not until 1902 that the railroad was able to obtain enough additional land to adequately expand the shops.

The railroad had buildings to repair, maintain, and service steam locomotives and freight and passenger cars, and the shops were the largest on the Union Pacific system west of Omaha, the company's headquarters. The shops were upgraded and expanded over the years, and there were many large and small buildings in the yards, ranging from the large machine shop to bunkhouses. In 1891, the railroad built a 35-stall brick roundhouse. In 1902, they added a machine and blacksmith shop, expanded the roundhouse, and built the transfer table. A new steel coach shop was built in 1905.

In 1924, the car shops included a coach shop, a steel car shop, a paint shop, and an upholstery shop capable of doing heavy and light repairs. In that year, the shops repaired 96,509 freight cars, 10,108 passenger cars, and 107,807 roadway cars.

With the advent of the diesel-electric locomotive, the large shops were no longer needed and were gradually torn down. The roundhouse and the coal tower were among the first buildings to be razed, although the turntable remained in use for several more years. The other buildings were used for a variety of railroad-related work over the years.

In 1973, the railroad spent $1.5 million and added onto the existing steel car shop so that the shops could perform heavy car repair work, restoring damaged and worn-out freight cars. The shops were closed in 1997 and the work transferred to De Soto, Missouri, and Palestine, Texas, a consequence of the mergers with the Missouri, Kansas & Texas and the Missouri Pacific railroads. The other maintenance work performed at Pocatello has also been discontinued so that only minimal repair and maintenance work is being performed at Pocatello today.

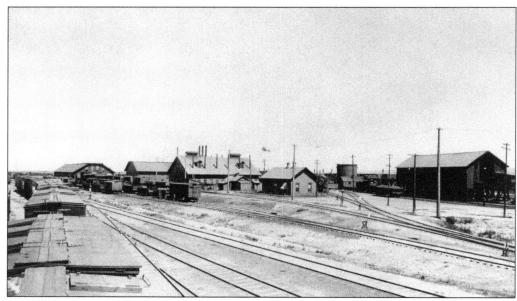

It is about 1895, and the Pocatello shops are busy repairing the freight cars lined up on the tracks in front of the car shops. The coal bunker is on the right with a water tank to its left. The locomotive shops are in the center, and the master mechanic's office is between the locomotive shop and water tank.

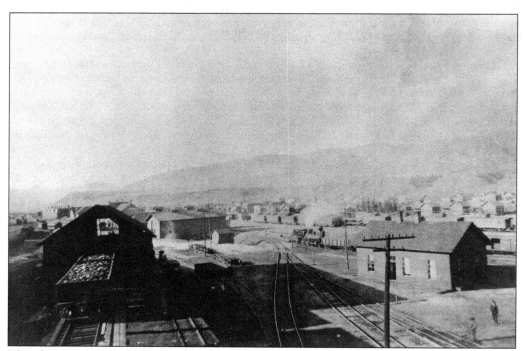

The photographer took this view looking over the coal bunker toward the depot around 1890, facing southeast toward what is now the downtown Pocatello business district. The master mechanic's office is to the right.

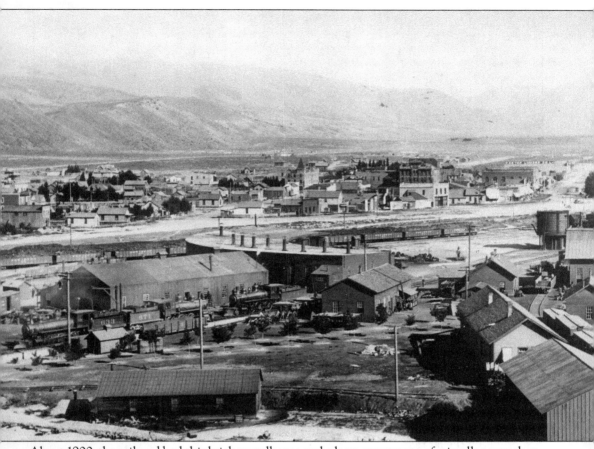

About 1900, the railroad had this brick roundhouse and a large assortment of miscellaneous shop buildings in the Pocatello yards. A water tank is on the right, and the edge of the coal bunker can be seen to the right of the water tank. A lawn with trees has been planted near the buildings in the foreground, seemingly out of place in the middle of the shop buildings. The railroad constructed a large number of buildings to service and maintain the locomotives and cars at Pocatello in a seemingly haphazard manner. The Portneuf Gap is in the background on the right.

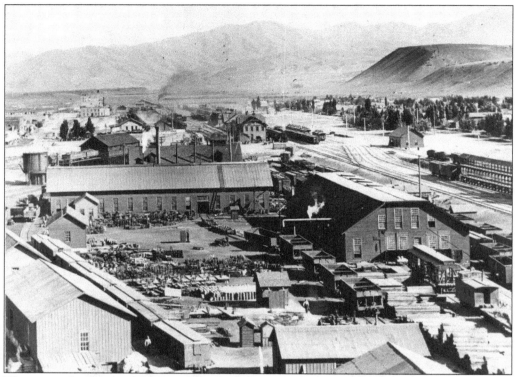

This is another view of the Pocatello yards showing the water tank and coal bunker on the left. The depot is in the center background, and the car shops are in the foreground with piles of lumber ready to be used to repair and build the wood freight and passenger cars. A group of open hopper cars is being repaired or built to the left of the car shop. The refrigerator-car icing platform is on the far right.

At the beginning of the 20th century, the railroad had its own boiler house to supply steam. The smokestack and boiler and coal houses are seen in this photograph. (Union Pacific Museum collection.)

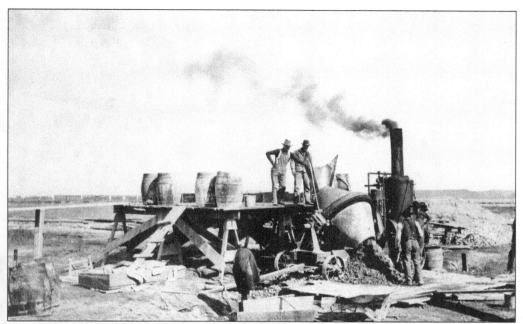

A modern steam-powered mixer was used to mix the concrete used for the new shop buildings that were constructed in 1902. The steam-powered cement mixer was a relatively new development, and the railroads were at the forefront of technology, using modern equipment such as this in an effort to reduce the costs and time needed to build their facilities. The new shops even had machinery using electric motors instead of the older machines driven using overhead belts.

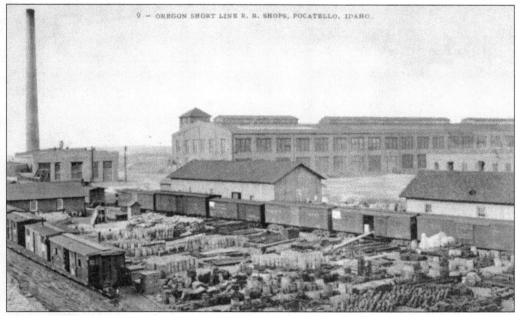

This postcard of the Pocatello shops shows the powerhouse on the left and the shop buildings in the background. The railroad required large quantities of supplies and materials, some of which are being stored in the foreground.

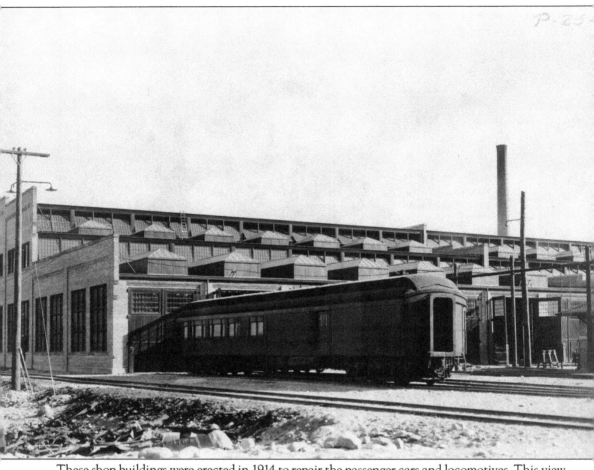

These shop buildings were erected in 1914 to repair the passenger cars and locomotives. This view of an Oregon Short Line wood combination car on one of the tracks going into the building was taken shortly after the building was completed. (Union Pacific Museum collection.)

The machine shops overhauled and rebuilt steam locomotives. The large 100-ton bridge crane could pick up an entire locomotive. It was being tested when this photograph was taken in 1902.

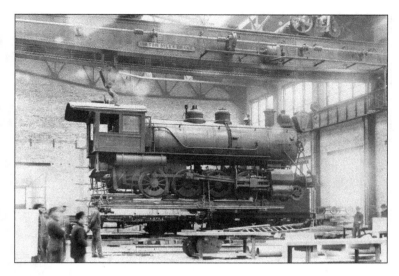

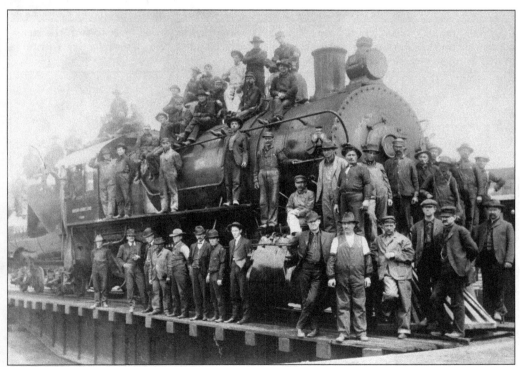

Steam locomotives required a large workforce to maintain and repair them, and it was a hard, dirty job, as evidenced by the clothes the men are wearing. Locomotive No. 1020 (shown on the turntable) was a Consolidation with a 2-8-0 wheel arrangement, built in 1904 by the Baldwin Locomotive Works. Railroaders of the period all wore hats, and the officials wore suits with ties and vests. This view was taken about 1908.

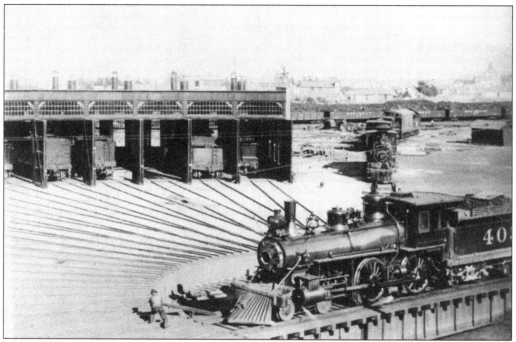

It is 1904, and an Oregon Short Line employee is using the long wood lever to turn the steam locomotive on the "Armstrong" turntable. It was replaced a few years later by a new turntable rotated using an electric motor.

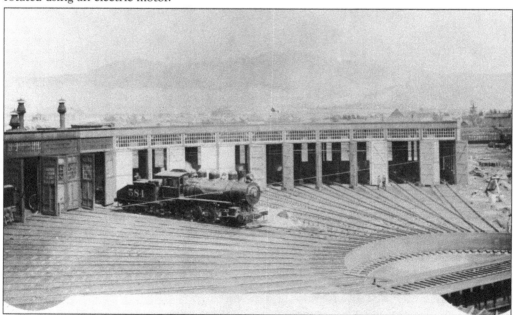

A steam locomotive is resting in front of the roundhouse in this view taken about 1903 with the manually operated turntable in the foreground. The roundhouse had just been expanded with 10 new stalls on the right side. The roundhouse had so many tracks that the rails overlapped at the turntable pit.

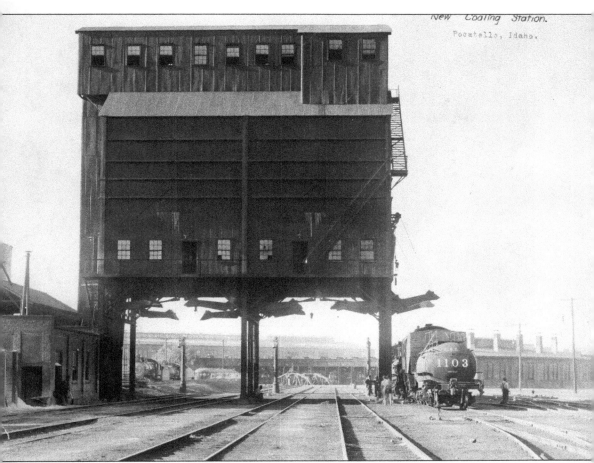

New Coaling Station.

Pocatello, Idaho.

The 900-ton coaling tower could supply coal to steam locomotives on five different tracks. It was built in 1913 when a major expansion of the shops was performed and was torn down in 1956 after the steam locomotives had been taken out of service. The roundhouse, turntable, and machine shop can be seen behind the coaling tower. A McKeen motorcar is in the background behind the left side of the coaling tower. These motorcars were used to replace passenger trains on lines that had little passenger traffic. (Union Pacific Museum collection.)

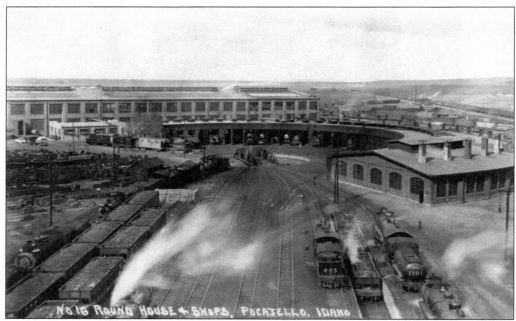

This view of the Pocatello roundhouse and machine shop building was taken from the coaling tower. The roundhouse was later expanded to 53 stalls and was busy 24 hours a day servicing, turning, and repairing steam locomotives. The machine shop building used for heavy repairs is behind the roundhouse.

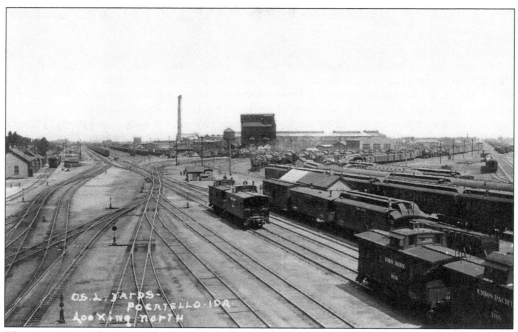

This is a view of the Pocatello shops with the coaling tower and power plant stack towering over the shop buildings. The main line to the West Coast is on the left, and the line north to Montana is on the right. The railroad had a large number of steam locomotives working out of Pocatello.

The relay office at the Pocatello depot was an important part of the railroad operations, controlling the train operations and sending messages throughout the railroad. They used the manual typewriter and the telegraph keys on the right. Railroad workers were almost all men, as seen in this 1908 scene. (Union Pacific Museum collection.)

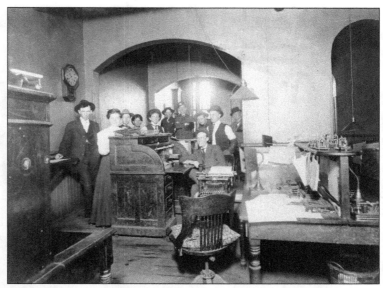

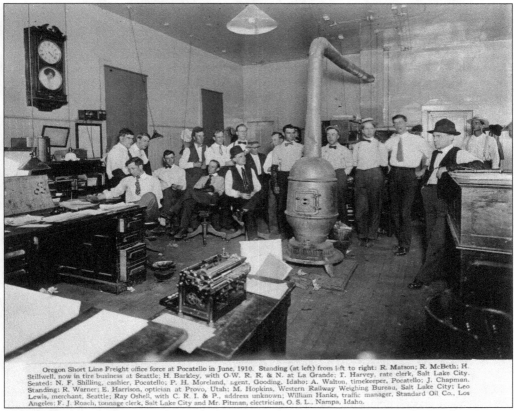

Oregon Short Line Freight office force at Pocatello in June, 1910. Standing (at left) from left to right: R. Matson; R. McBeth; H. Stillwell, now in tire business at Seattle; H. Barkley, with O-W. R. R. & N. at La Grande; T. Harvey, rate clerk, Salt Lake City. Seated: N. F. Shilling, cashier, Pocatello; P. H. Moreland, agent, Gooding, Idaho; A. Walton, timekeeper, Pocatello; J. Chapman. Standing: R. Warner; E. Harrison, optician at Provo, Utah; M. Hopkins, Western Railway Weighing Bureau, Salt Lake City; Leo Lewis, merchant, Seattle; Ray Oshell, with C. R. I. & P., address unknown; William Hanks, traffic manager, Standard Oil Co., Los Angeles; F. J. Roach, tonnage clerk, Salt Lake City and Mr. Pitman, electrician, O. S. L., Nampa, Idaho.

This view taken in June 1910 shows the large crew that worked in the Pocatello freight office. In the winter months, the room was heated with the potbelly stove, and the men used the spittoons on the floor, a common furnishing of the era. The lighting was provided by the knob-and-post wiring seen on the walls and ceiling. (Union Pacific Museum collection.)

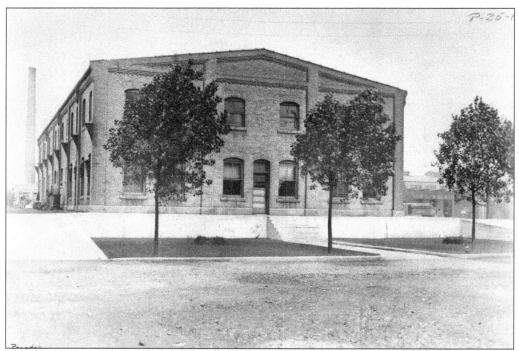

The storehouse was built in 1910 to hold the wide variety of materials used in the Pocatello shops. The trees and grass seem incongruous because the building is in the middle of the yards, which had steam locomotives spewing cinders and smoke into the air 24 hours a day. (Union Pacific Museum collection.)

The storehouse was a simple, solid-brick building. It was expanded in 1923 and later converted into the signal shop, as seen in this 1995 view taken shortly before it was razed. When the storehouse was torn down, small iron rails were found in the window frames, probably scrap rail from the narrow gauge Utah & Northern. The railroad recycled many items and materials in an effort to economize. (Photograph taken by Thornton Waite.)

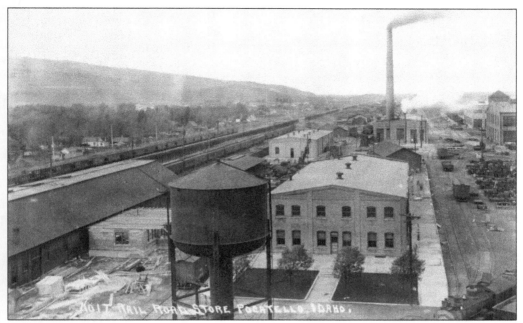

Looking west from the coaling tower, a water tank and the storehouse are in the foreground, and the powerhouse is in the background. The main line to the West Coast is on the left, and the shops are on the right. Large quantities of supplies and materials are stored on the ground in the shop area.

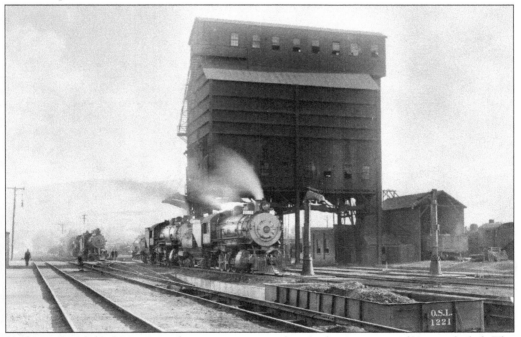

In this view of the 900-ton coaling tower, a pair of steam locomotives is being refueled. The gondola in the foreground is holding clinkers from the steam locomotives, the residue of the coal used for fuel. (Union Pacific Museum collection.)

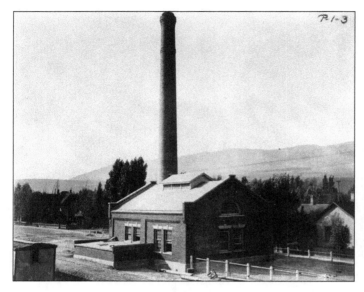

The railroad built a small powerhouse to the south of the depot to provide steam to the depot and for the railroad cars spotted on the tracks in front of the depot. It was torn down in 1985 when it was no longer needed and replaced by a parking area. A larger powerhouse was also built at the other end of the yards for the shop buildings. (Union Pacific Museum collection.)

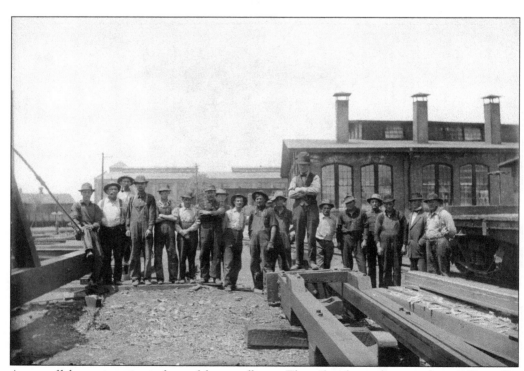

A crew of laborers is posing in front of the roundhouse. The railroad was a large employer in Pocatello, hiring men for work occupations ranging from managers to engineers to section crews.

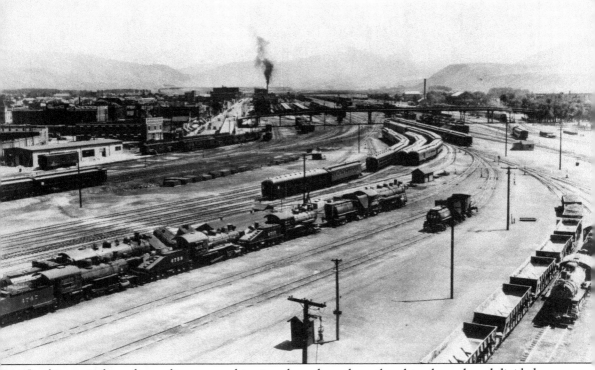

Looking east from the coaling tower, this view shows how the railroad tracks and yard divided the city of Pocatello. The yards are full of passenger cars and freight cars, and a large number of different types of steam locomotives can be seen on the various tracks. A string of cabooses is under the right-hand side of the Center Street viaduct. The depot is to the right of the smokestack on the right, and the freight house and freight house platforms are on the left behind the Center Street viaduct. (Union Pacific Museum/George Cockle collection.)

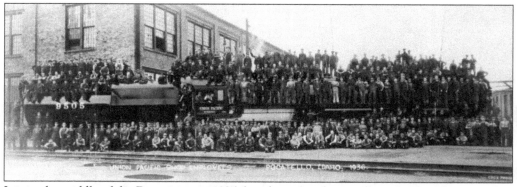

It is in the middle of the Depression in 1936, but the railroad was still employing a large number of men, shown posing on steam locomotive No. 9505, a 4-12-2 built in 1930.

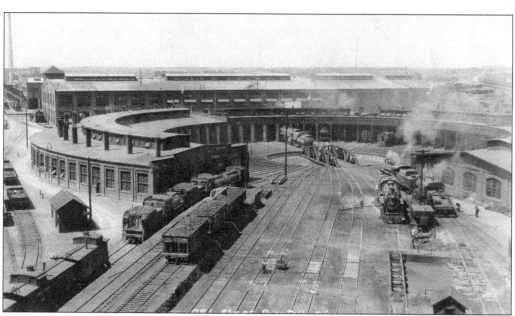

The roundhouse was expanded over the years so that the 53 stalls made almost a complete circle. The machine shop building is behind the roundhouse.

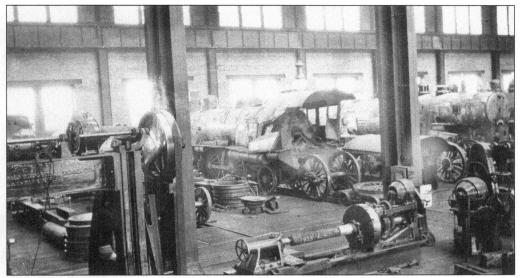

The Pocatello shops performed activities ranging from routine maintenance to major overhauls and repairs. This locomotive being repaired in the Pocatello shops in 1905 was wrecked in a collision at Eaton, Idaho.

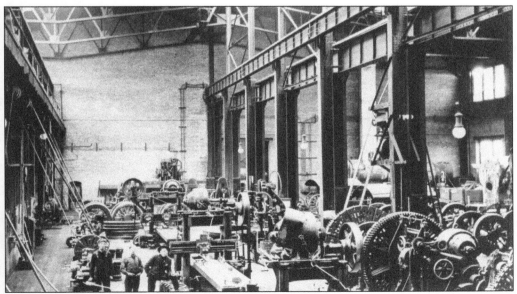

The railroad owned and operated a wide variety of machinery to maintain the steam locomotives. The shops performed major and minor overhauls and employed a large number of men who worked in the shops, which were in service 24 hours a day.

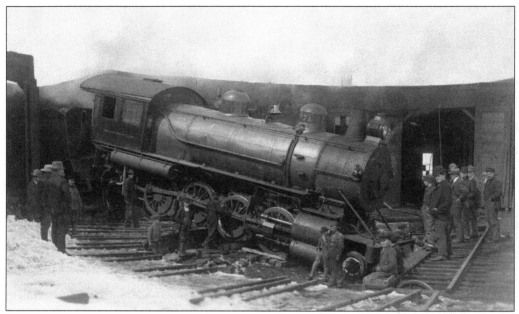

Once in a while, a steam locomotive was not stopped in time and fell into the turntable pit. This view is believed to have been taken at the Pocatello roundhouse about 1900, showing a large number of bystanders, including some children in the foreground.

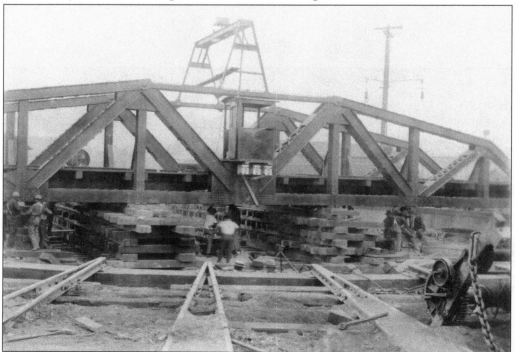

The railroad installed a new 100-foot electrically powered turntable in 1913. The turntable had to be installed quickly so that daily operations were not interrupted for an extended period of time. (John Aguirre collection.)

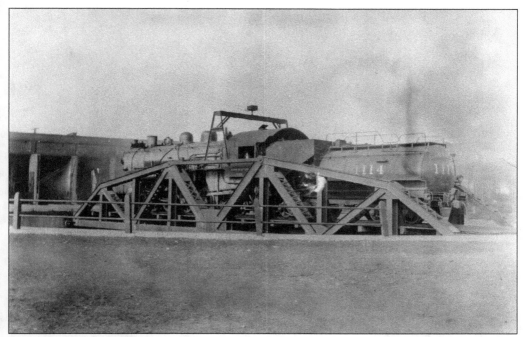

The new Pocatello turntable could handle steam locomotives up to 100 feet long. It was essentially a small truss bridge that rotated around a central pivot point and was operated using an electric motor. (John Aguirre collection.)

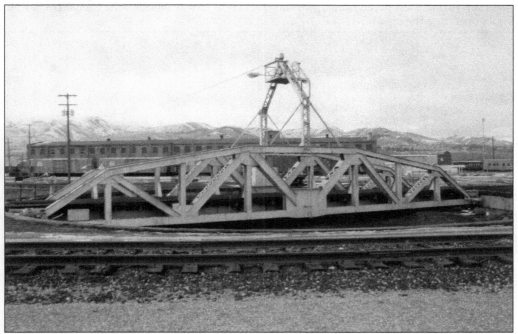

The turntable was replaced with a stronger one in 1926 that was used into the 1990s, but has since been removed. It was used to turn steam locomotives and to move them into the roundhouse bays. (Photograph taken by Thornton Waite.)

The Pocatello roundhouse had just been placed in service when this view was taken in 1903, and it will not be long before the roof rafters are covered with soot. The railroad shops were an important part of the local economy, providing numerous jobs to maintain the equipment as well as jobs operating the trains.

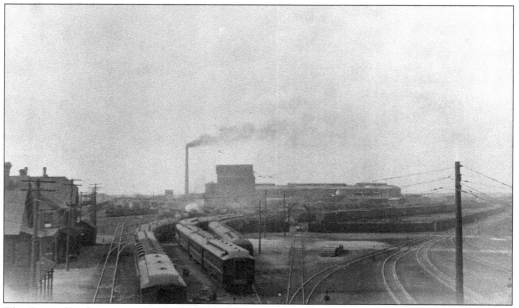

The Pocatello shops are seen from the Center Street viaduct in this view taken in about 1914, just before the new depot was built. The smoke coming out of the powerhouse smokestack and the hazy atmosphere were considered signs of prosperity.

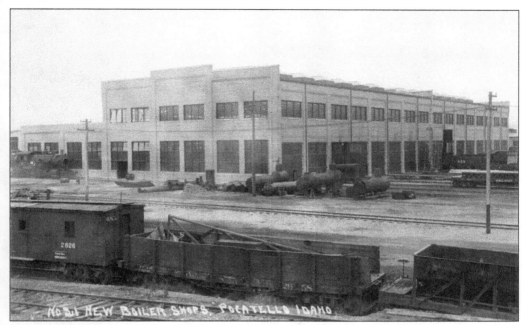

The new coach, boiler, and tender shop building was completed in 1914. The steam locomotives required periodic maintenance and inspections, which were labor-intensive jobs. Spare boilers and other equipment were stored outside for possible future use. The shop building had large panels of windows for natural lighting.

The railroad had both large and small buildings in Pocatello, such as this small, 30-foot-by-50-foot blacksmith shop in this picture taken in 1929. It had corrugated iron sides and a composition paper roof, typical of the small, temporary buildings in the Pocatello shops. (John Aguirre collection.)

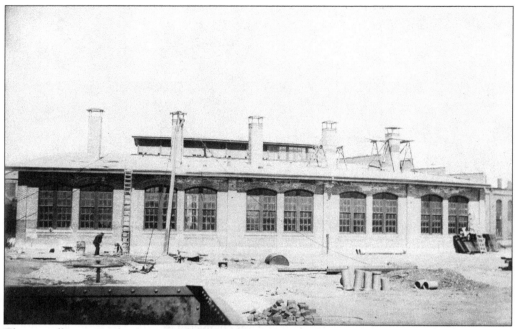

The roundhouse was being expanded when this photograph was taken. The smokestacks of the steam locomotives were spotted below the smoke jacks to allow their exhaust to escape from the roundhouse.

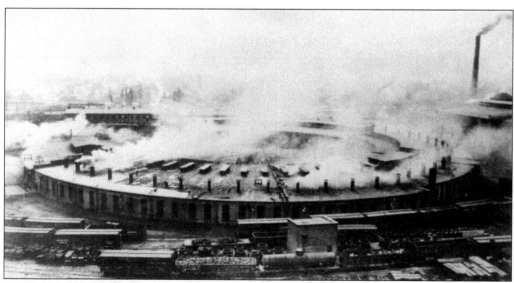

This aerial view of the Pocatello roundhouse shows smoke pouring out of the structure's many smoke jacks. At one time, the Pocatello roundhouse had 53 stalls and was the largest roundhouse on the Union Pacific system. (John Aguirre collection.)

In this view taken in 1972, the machine shop is being torn down because it was no longer needed to maintain locomotives. The foundation for the roundhouse can be seen on the left, and the tracks are being used to store maintenance equipment. The boiler shop building in the background was used for a variety of purposes in the following years, but it was razed in 2010.

The roundhouse was torn down in stages, as seen in this photograph taken about 1972 when the machine shop was being torn down. The roundhouse tracks are being used to store diesel-electric locomotives and other equipment such as the rotary snowplow.

The railroad had a transfer table between the machine shop and coach and boiler shop, used to move cars and locomotives between the two buildings. In the fall of 2010, the transfer table was removed and the pit was filled in. (Photograph taken by Thornton Waite.)

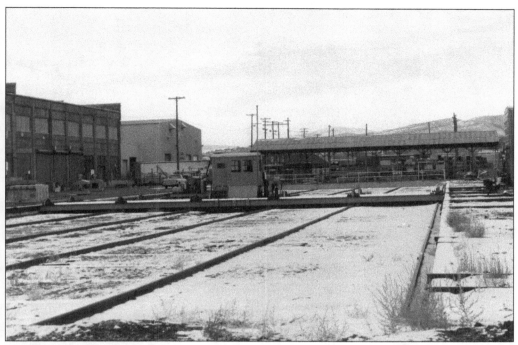

This is a view of the transfer table taken in 1988 after the machine shop had been razed but while the coach and boiler shop was still being used for other car maintenance and repair work. (Photograph taken by Thornton Waite.)

In 1979, the Union Pacific Railroad opened its new heavy-car-dismantling facilities. Various car parts were stored and repaired in work areas that were sectioned off. The new diesel shop building is in the background. (Union Pacific Museum collection.)

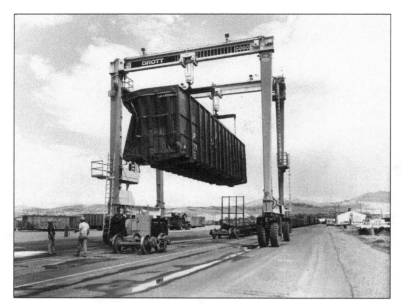

A large mobile Drott crane in the heavy-car dismantling facilities picked up entire car bodies and moved them off the tracks to a work area where the repairs were then made. (Union Pacific Museum collection.)

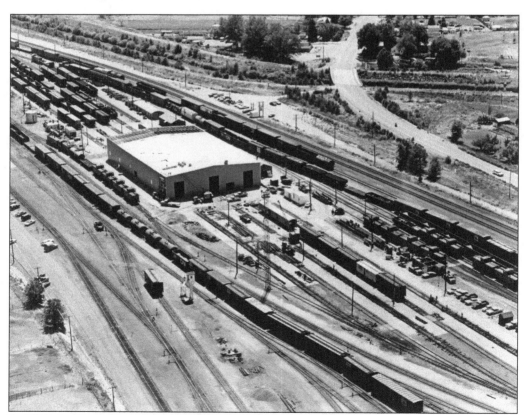

In 1974, the Union Pacific opened a new $1.5 million One Spot car repair shop near the gravity switching yard. Used to make minor car repairs, it is still in operation today. (Union Pacific Museum collection.)

The railroad operated a wheel shop at Pocatello for many years. The used and newly trued wheels were stored and shipped on special flatcars. The wheel shop was closed in 1999.

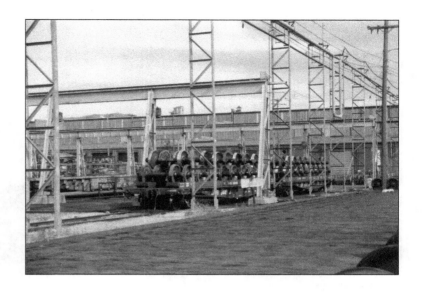

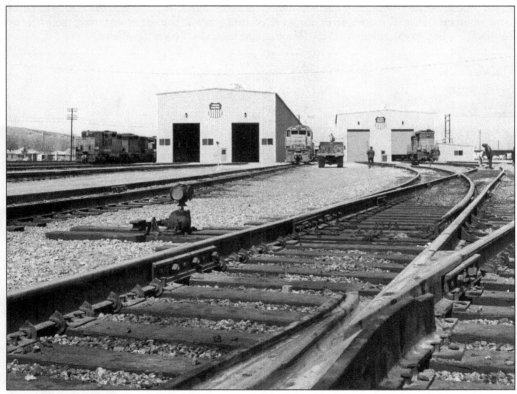

The Union Pacific opened a new $1.4 million diesel shop in 1972 to perform light repairs and maintenance. The large, open-air building is still in use today. (Union Pacific Museum/George Cockle collection.)

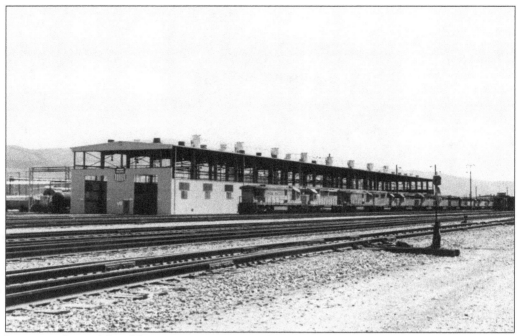

Large numbers of diesel locomotives are serviced every day at the diesel servicing facilities, as seen in this photograph taken in 1989. (Photograph taken by Thornton Waite.)

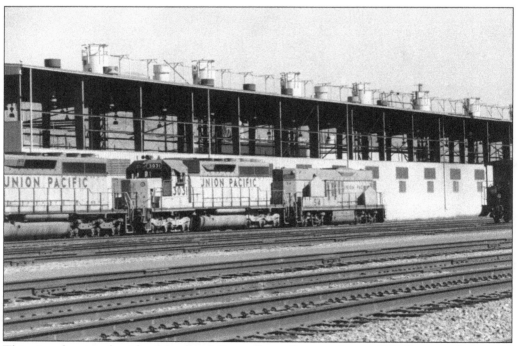

This view showing the side of the diesel shop at Pocatello was taken in 1989. It is a modern metal building with two through tracks that can accommodate several locomotives at the same time. (Photograph taken by Thornton Waite.)

This view shows the inside of the diesel shop. The pit under the tracks allows easy inspection of the underside of the locomotives. Minor maintenance and repairs are performed in the building. (Union Pacific Museum collection.)

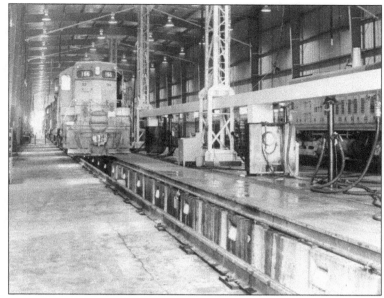

For many years, Pocatello had a crematory where old wooden freight cars were burned to reclaim the metal parts and where steam locomotives were stored before they were scrapped. The steam locomotives on the right have been retired and boarded up and are awaiting an uncertain future, while the freight cars are being scrapped.

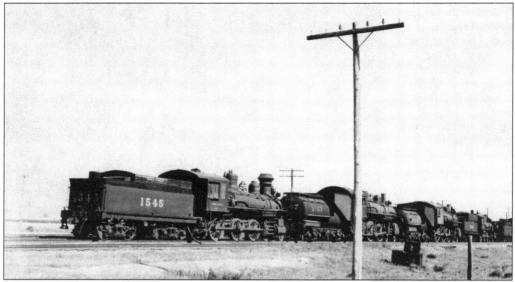

A long string of steam locomotives with the windows boarded over are on the dead line around the year 1923. They will be used when there is enough business to justify bringing them back into service, or else they will be scrapped.

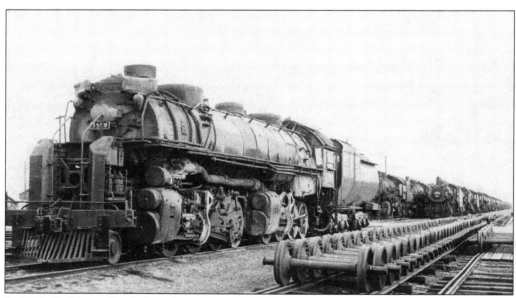

In 1954, the Union Pacific has almost completed the transition from steam locomotives to diesel-electric locomotives. These steam locomotives have been taken out of service and are being retired. The windows and number boards are all covered over, a standard practice for retired or stored locomotives.

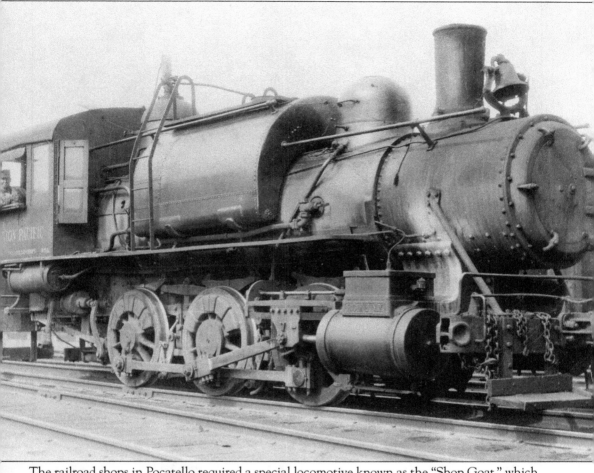

The railroad shops in Pocatello required a special locomotive known as the "Shop Goat," which could move the steam locomotives and rolling stock to and from the shops. This unique "dinky" was used in the Pocatello shops for many years. (Union Pacific Museum collection.)

Pocatello Shop Goat No. 4407 was built by the Baldwin Locomotive works in 1913 and removed from the roster in 1956. It was the last steam Shop Goat used at Pocatello. (Union Pacific Museum collection.)

The engineer (second from right) for the Shop Goat is retiring and is being congratulated by railroad officials and fellow workers. The engineer on this job had a job with regular hours that did not involve travel and layovers at another division point.

In 1974, the Union Pacific was using this small Shop Goat built by the Whitcomb Locomotive Works. Originally used by the Boeing Company, it then worked at the Union Pacific's North Platte yards. It was used for two years at Pocatello before being retired and sold. The railroad then began using a Trackmobile, which is essentially a tractor that can be used either on railroad tracks or on a road.

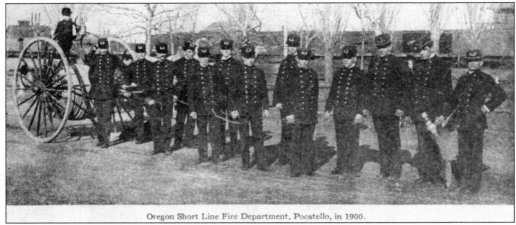

Oregon Short Line Fire Department, Pocatello, in 1900.

Feeling it was safer and better to have their own men fight fires in the busy yards, the railroad maintained its own fire department for many years. Seen in this 1900 photograph, this crew had its own uniforms and hose wagon. In 1924, the fire department had a two-story fire station with a dormitory on the second floor, a fire alarm system, and a firefighting crew consisting of a fire chief, two truck drivers, and volunteer firefighters. The fire department chief had his own custom-equipped Ford car with a 25-gallon chemical fire extinguisher. The fire crew had a White fire truck, 1,000 feet of fire hose, and all of the modern firefighting equipment. A four-man crew slept in the firehouse dormitory. (Union Pacific Museum collection.)

The first YMCA in Pocatello was in this small, wooden building on Harrison Street. It was used from 1888 to 1897 when it became too small to accommodate the increasing number of visitors. The YMCA also had buildings at Montpelier and Glenns Ferry in southern Idaho for the train crews laying over between runs.

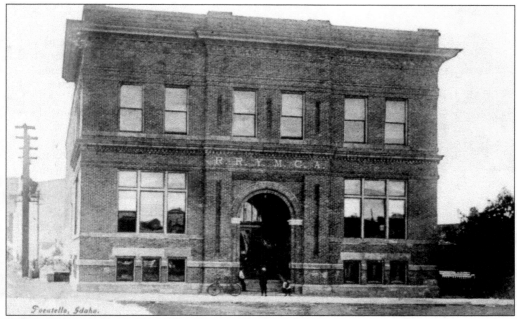

The YMCA built a new, $50,000 building on North Arthur Street in 1907. It had sleeping quarters, a swimming pool, gymnasium, and classrooms, and the facilities were used by hundreds of railroad workers and their families for many years.

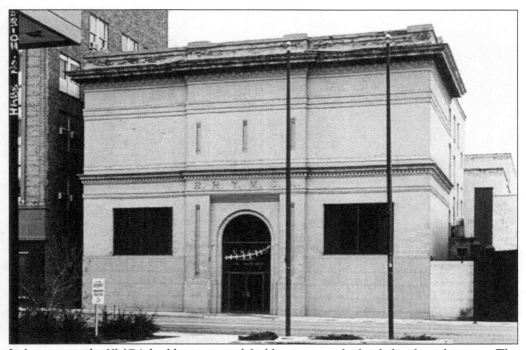

In later years, the YMCA building was modified by covering the brick facade with stucco. The building was torn down in the 1980s, and an archway reminiscent of the building was erected at the location. (Historic American Building Survey.)

Located at the Naval Ordnance Plant, the Pocatello Assembly Facility Company had this 44-ton General Electric switcher lettered for PAFCO. It was switching the facility tracks when this picture was taken on September 5, 1988. The plant no longer requires its own switcher but is still being used by a wide variety of businesses. (Bryan Griebenow, George R. Cockle collection.)

Located to the west of Pocatello, the J.R. Simplot Plant owns a switcher to move the cars of ore and product. In September 1988, the plant was using this ex–Southern Pacific ALCO. Although this locomotive has since been retired, the plant continues to use its own switching locomotive. (Bryan Griebenow, George R. Cockle collection.)

Eight

PACIFIC FRUIT EXPRESS

The Pacific Fruit Express Company was formed in 1906 by the Union Pacific and Southern Pacific Railroads to jointly own and operate a large fleet of refrigerator cars. This new company improved the utilization of the refrigerator cars, since the crops shipped over the two railroads were harvested at different times in the year. The refrigerator cars were cooled with ice, typically in large blocks. In the years before artificial refrigeration, the railroad harvested ice from ponds in the winter months, stored it in large insulated storehouses, and then used it to ice the cars in the summer months.

Pocatello was a major icing and re-icing station where refrigerator cars for potatoes shipped from southern Idaho were iced and ice was added to the cars holding fruits and vegetables being shipped from Idaho, Oregon, and Washington to the East Coast.

Following World War I, Pacific Fruit Express began making its own ice in new refrigeration plants, including one built at Pocatello. Constructed in 1922, this ice plant could make 125 tons of ice a day and had a storage capacity of 18,700 tons of ice. There was an icing platform that could re-ice 85 cars on each side. The platform was lengthened by 968 feet in 1960 to increase the number of cars that could be iced simultaneously. A shorter platform was used for the westbound trains.

Between 1923 and 1925, Pacific Fruit Express built light-repair and maintenance shops in Pocatello, upgrading the smaller facilities being used there. The shops were expanded in 1949, and the Pacific Fruit Express shops at Nampa were moved to Pocatello in 1957.

With the advent of mechanical refrigerator cars that had individual refrigeration units, icing was no longer required, and the last refrigerator cars using ice were taken out of service in 1971. The icing platform was torn down and the icing plant closed.

In December 1977, Pacific Fruit Express was broken up into two separate companies: Union Pacific Fruit Express (UPFE) and Southern Pacific Fruit Express (SPFE). Ironically, the Union Pacific absorbed the Southern Pacific in 1996, and the UPFE and SPFE companies merged back together. After consolidating some of the work at Pocatello, the Pacific Fruit Express shops were closed in 2002.

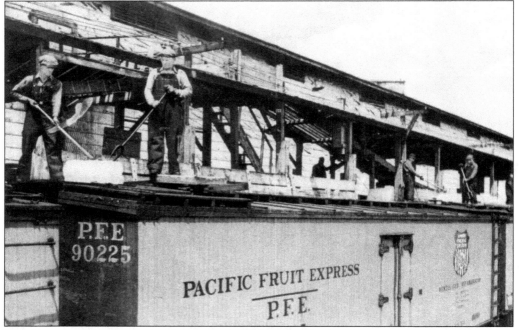

To add ice to the refrigerator cars, men would slide the blocks of ice into the open hatches on the top of the refrigerator cars, as seen in this Union Pacific advertisement. In the peak season, Pacific Fruit Express employed 200–275 men at Pocatello. (Union Pacific Museum collection.)

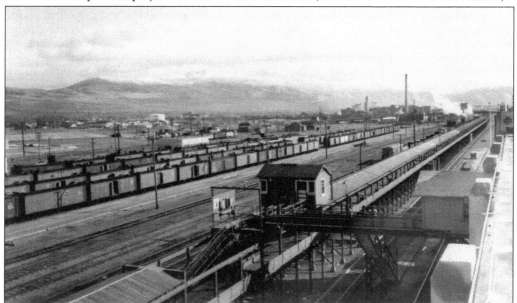

The icing platform could re-ice 85 cars on each side. Mechanical conveyors moved the ice from the insulated icehouse up onto the icing platform. The Pacific Fruit Express shop buildings are on the left side of the tracks. The power plant stack and shop buildings are in the background. Today only part of the ice plant remains, and the icing docks have all been removed. (Pocatello Model Railroad & Historical Society.)

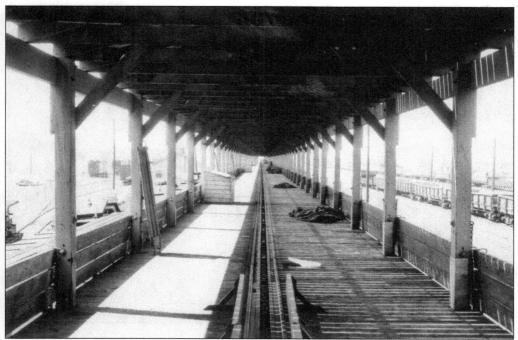

As seen here, the ice is moved along the icing platform using the conveyor in the center of the covered platform. The shelter kept the ice from being in the direct sunlight. The blocks of ice were pushed and pulled down planks to the hatches on the top of the refrigerator cars. (Pocatello Model Railroad & Historical Society.)

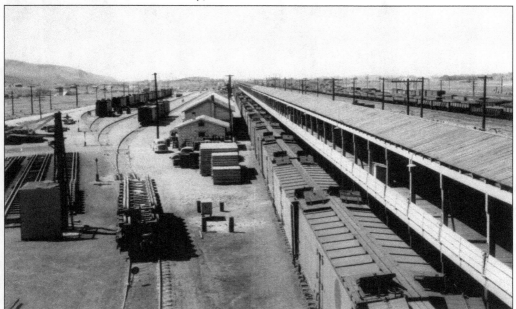

A string of refrigerator cars is pictured at the Pocatello icing dock with the icing hatches raised to receive the blocks of ice. In the 1949–1950 season, the railroad re-iced 36,309 cars with solid trains of refrigerator cars stopping at the icing docks. (Pocatello Model Railroad & Historical Society.)

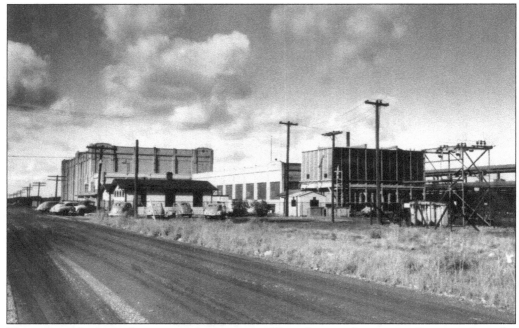

The railroad built a refrigeration plant so it would not have to harvest ice from ponds in the winter months. The ice plant manufactured ice and stored it in the large, insulated icehouse seen in the background. The remains of the ice plant are on the west side of town. (Pocatello Model Railroad & Historical Society.)

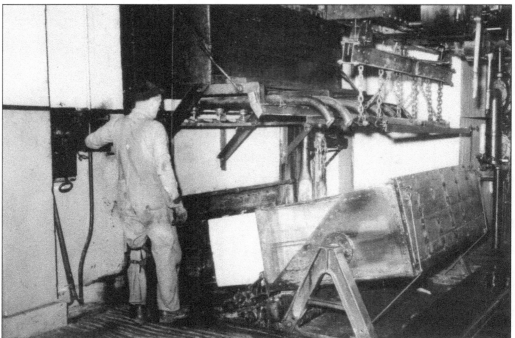

Water was poured into rectangular cans to form large blocks of ice. The standard block of ice weighed 300 pounds. (Pocatello Model Railroad & Historical Society.)

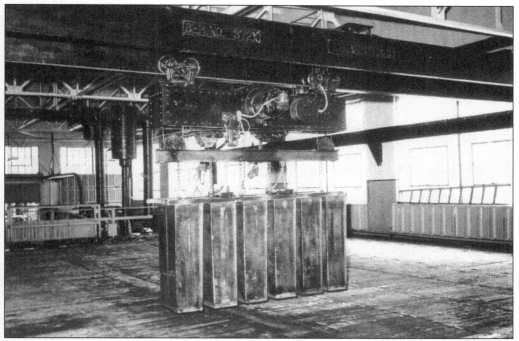

The ice plant had overhead cranes to move the ice cans around. Icing was a seasonal activity with the peak demand occurring during the harvest seasons. (Pocatello Model Railroad & Historical Society.)

After the ice was removed from the cans, it was stored in the large, insulated icehouse, ready to be used in refrigerator cars. (Pocatello Model Railroad & Historical Society.)

The icehouse is seen filled with the large blocks of ice, ready to be transferred to the icing platform. The small ridges on the ice blocks were intended to keep them from freezing together. (Pocatello Model Railroad & Historical Society.)

Pacific Fruit Express erected several shop buildings to repair and maintain its refrigerator cars. The buildings included this structure, used to cut the wood for the car interiors. (Union Pacific Museum.)

Nine

THE TIMBER
TREATING PLANT

Pocatello once had one of three plants on the Union Pacific Railroad used to treat railroad ties with preservative, which extended the life of the ties. At the Timber Treating Plant, the ties were put on narrow gauge railcars and the cars were run into large retort vessels. The moisture in the wood was pulled out using a vacuum and the retort was then flooded with preservative and placed under pressure at an elevated temperature to force the preservative into the wood. The treated ties were then stored outside until they were needed. The wood was initially treated using zinc chloride for the preservative. This chemical was later superseded by creosote.

Located on the west side of Pocatello, the 51-acre Timber Treating Plant was opened in 1921 and had a capacity of 6,000 ties a day. The wood was received, cut to the desired size, and dried. It was next treated with preservative and stored on the site until needed. The tie plant treated not only railroad ties but other pieces of lumber, as well as telegraph poles and wood structural pieces for bridges. Until the Depression, most of the wood used for the ties, structural pieces, and poles came from the Island Park region on the Yellowstone Branch of the railroad. After that, the ties came from McCall, Idaho, and Green River, Wyoming.

Typically, 55 men worked at the tie plant, moving the ties around the plant and between the tramcars and the staging areas used for curing and storage. The 30-inch narrow gauge railroad was used to move the ties in and out of the retort vessels. The plant was closed in 1948 and the facilities torn down. The site was then used by the railroad as a disposal site. The area was later placed on the Environmental Protection Agency's Superfund list to remediate it, which was performed in 1994. The tie plant site now has tracks used to stage trains and store excess railroad cars.

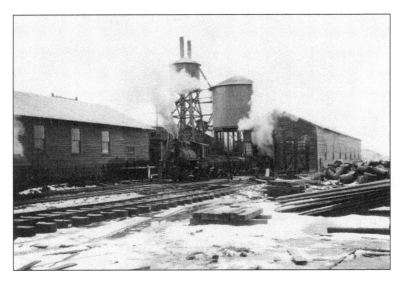

The Timber Treating Plant had a large wooden building that held the retorts used to add the preservative to the wood. A narrow gauge railroad was used to move the ties in and out of the retorts. The large overhead tank held the preservative while the small tank held water. (Union Pacific Museum collection.)

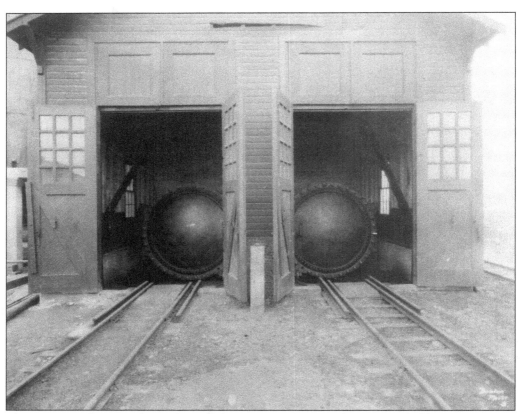

The retort vessels were 7 feet in diameter by 132 feet in length. The tramcars holding the ties were rolled into the vessels, the door closed, and the ties vacuum-dried and treated with preservative at a high temperature and pressure. (Dean Burgess/Thornton Waite collection.)

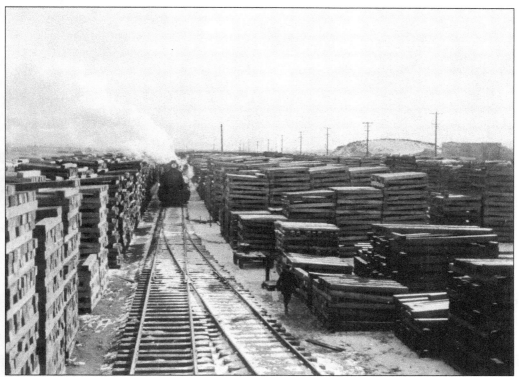

The newly cut ties and the treated ties were all stored on the 51-acre tie plant site. Workers would manually move the ties to and from the stacks onto the tramcars. After being treated with preservative, the ties were distributed over the railroad lines wherever they were needed. (Union Pacific Museum collection.)

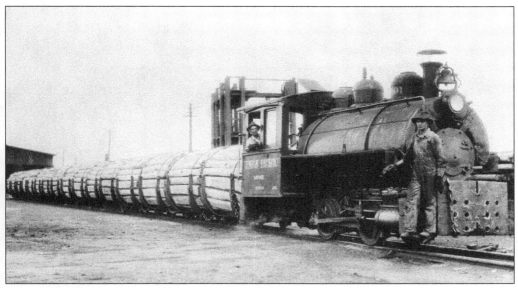

A small, narrow gauge dinky locomotive moved the tramcars holding the ties in and out of the retort and to and from the storage area. (Union Pacific Museum/George Cockle collection.)

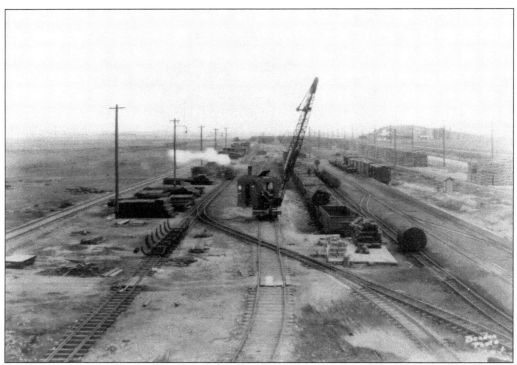

A railroad crane is seen loading treated ties into a gondola for use along the railroad. The standard gauge tracks were slightly depressed to make loading easier. Some empty tramcars are on narrow gauge tracks on the left. (Dean Burgess/Thornton Waite collection.)

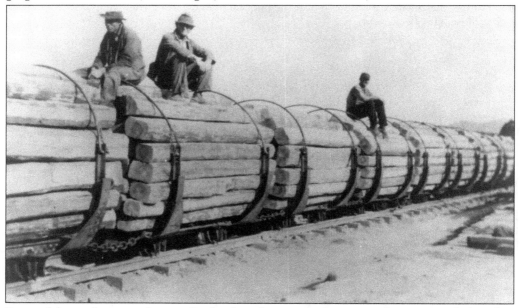

Some of the workers are relaxing after loading the untreated ties onto the tram cars before they are moved into the retort for treatment. This photograph reportedly shows the first load of ties being treated in the retort. (Fred Dykes collection.)

Ten

POCATELLO'S
RAILROAD HERITAGE

Although the shops, hump yard, refrigerator car facilities, and most of the other maintenance facilities are gone, the railroad maintains a significant presence in Pocatello today. Transporting large volumes of freight through Pocatello, the Union Pacific is one of the biggest railroads in the country, and the city remains an important division point.

The railroad depot at Harrison Avenue is still used by the railroad for offices and other related work with the trains running past it 24 hours a day. The depot parking lot is used by the train crews to park their vehicles while they make their runs east to Green River, Wyoming, west to Nampa, Idaho, south to Ogden, Utah, and north to Dillon, Montana. The coaling tower was razed in 1956, and the machine shop was torn down in 1972. The dispatcher's office was closed in 1985. The signal shop was closed in 1993 and the work transferred to Sedalia, Missouri.

Many of the remaining shop buildings were torn down in the fall of 2010, and the Pacific Fruit Express buildings are currently being used for the repair and maintenance of unit train cars. The dispensary was razed in early 2011, but the landmark power plant stack on the west end with the large *Union Pacific* lettering remained standing in early 2012. The hump used to sort the cars is gone and the classification yard tracks have been removed. However, the One Spot repair shop is still being used. The tie plant tracks on the west end of town are used to store and stage freight trains.

There are three pieces of railroad equipment on display at Ross Park next to the railroad tracks near the mainline tracks. There is also a small exhibit on the Idaho State University campus on the route of the original narrow gauge Utah & Northern, comparing the original narrow gauge and contemporary standard gauge rails. The mural over the depot main entrance is now at the Stephens Performing Arts Center on the Idaho State University campus. The Bannock County Museum also had an exhibit showing the history of the railroad in Pocatello.

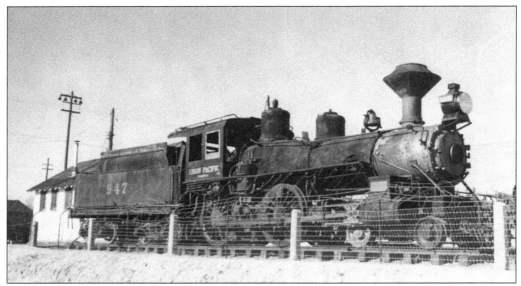

During the Depression, the Union Pacific donated two steam locomotives for display on the University of Idaho's Southern Branch campus, known today as Idaho State University. Built in 1891, one of the locomotives was 4-4-0 No. 947 and the last locomotive of that type on the railroad. It was donated in 1936.

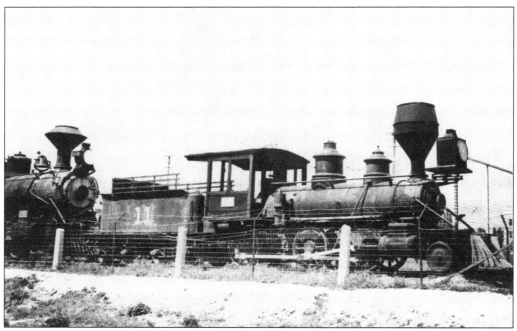

The other locomotive was former Utah & Northern narrow gauge 2-6-0 No. 11, built by the Baldwin Locomotive Works in 1879 and moved onto the campus in 1937. This one came from the Sumpter Valley Railroad, a logging line near Baker, Oregon. Both locomotives were cut up in 1942 during a World War II scrap metal drive.

There is a small exhibit on the Idaho State University campus comparing the narrow gauge Utah & Northern and contemporary Union Pacific tracks. The original route of the Utah & Northern ran across what is now the campus. (Photograph taken by Thornton Waite.)

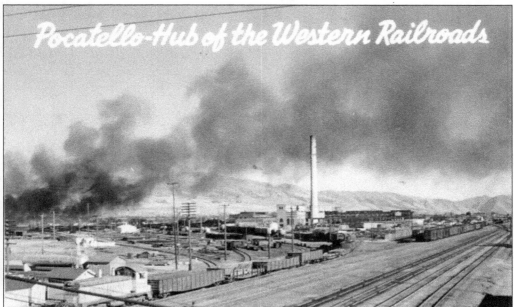

This postcard view was taken from the Gould Street overpass, showing the vast Pocatello shops. Based on the cloud of steam on the left and diesel-electric switcher in the foreground, the photograph was probably taken in the early 1950s.

The west part of the icehouse burned down, but the refrigeration plant is still standing, although no longer used to make ice. The buildings are rented out to non railroad-related businesses. (Photograph taken by Thornton Waite.)

The Pacific Fruit Express shops are no longer used, but the tracks and buildings remain, employed to repair and maintain the cars used in unit trains. The sign over the main entrance remains as a reminder of the time when the refrigerator cars were repaired in Pocatello. (Photograph taken by Thornton Waite.)

In 1958, the Union Pacific retired and donated steam locomotive No. 2005 to the city where it is on display in Ross Park. Built by the Baldwin Locomotive Works in 1891, it is similar to the one on display at the Boise station.

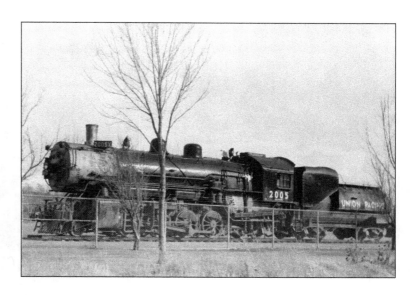

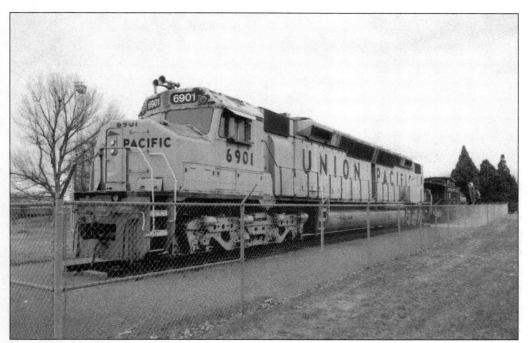

Union Pacific Centennial No. 6901 was donated to Pocatello in 1986 and is on display next to the No. 2005. It was one of the largest diesel-electric locomotives ever built. (Photograph taken by Thornton Waite.)

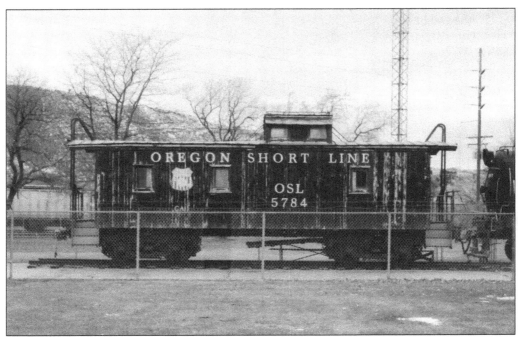

Oregon Short Line caboose No. 5784 is also part of the display at Ross Park. Originally numbered 2662, it has been painted and stenciled to look like it did when it was in service, complete with the Oregon Short Line shield. (Photograph taken by Thornton Waite.)

The railroad has influenced the growth and development of the city in many ways, including the establishment of a credit union for the railroad employees. The Pocatello Railroad Federal Credit Union is located convenient to the depot so that workers can go to the bank on their way to and from work. (Photograph taken by Thornton Waite.)

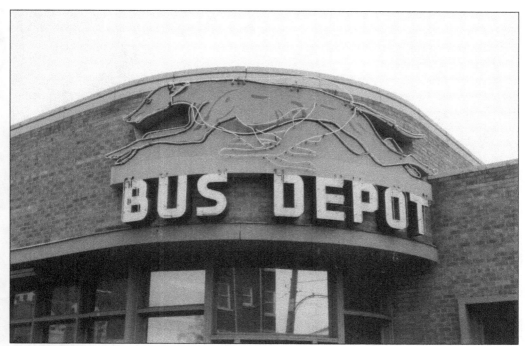

The Art Deco bus depot is still used by Pocatello Regional Transit (the local transit agency) and the Salt Lake Express. The Greyhound logo remains above the entrance to the bus depot, which has not been significantly altered over the years. (Photograph taken by Thornton Waite.)

The first hospital in Pocatello was opened by the Oregon Short Line in 1910. In 1951, the railroad opened a clinic in this new building in Manson Park near the depot. The dispensary was vacated in early 2011 and was about to be razed when this photograph was taken. (Photograph taken by Thornton Waite.)

A few small retail establishments, including a bar named the Depot, use the bottom floor of the Yellowstone Hotel, but the upper floors are no longer in use. The downtown hotel has been replaced by motels next to Interstates 15 and 86.

When the YMCA was torn down in the 1980s, the land was converted into a parking lot. An archway resembling the building front was built over the entrance with the letters YMCA on the side as a reminder of the former use of the site. (Photograph taken by Thornton Waite.)

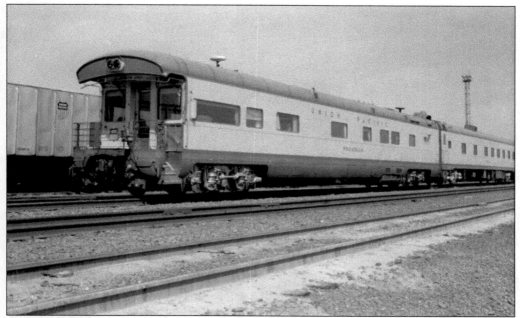

The Union Pacific Railroad has several business cars used by officials to inspect the lines and to show shippers how the railroad operates. In 1989, the Union Pacific Railroad changed the name of their business car No. 101 to "Pocatello." In 2001, the car was renamed the "Lone Star." The car was photographed at Council Bluffs, Iowa, on August 14, 1995. (George Cockle.)

Another business car owned by the Union Pacific Railroad is the "Idaho." Originally a sleeping car called "Western Mountain," it was rebuilt and named "Sun Lane" in 1965. In 1980, the car was rebuilt to an inspection car so that riders can look out the rear window as the train rolls down the tracks. (Photograph taken by Thornton Waite.)

In 1991, an eastbound freight train headed by Union Pacific No. 9400 was photographed approaching the Pocatello yards. The locomotive is a model C41-8W, built by General Electric in 1990 and rated at 4,100 horsepower. (Photograph taken by Thornton Waite.)

In February 2011, Union Pacific No. 8622 was at the front end of a westbound freight leaving Pocatello. It is a model SD70ACe built by Electromotive in 2008 and rated at 4,300 horsepower. (Photograph taken by Thornton Waite.)

FURTHER READING

Beal, Merrill D., and Merle Wells. *History of Idaho*. New York: Lewis Historical Publishing Company, 1959.

Beal, Merrill D. *Intermountain Railroads*. Caldwell, ID: Caxton Printers, 1962.

Colorado Railroad Annual No. 15. Golden, CO: Colorado Railroad Museum, 1981.

Federal Writers' Project of the Work Projects Administration. *The Idaho Encyclopedia*. Caldwell, ID: Caxton Printers, 1938.

Gittins, H. Leigh. *Pocatello Portrait: The Early Years, 1878 to 1928*. Moscow, ID: University of Idaho Press, 1983.

Link, Karl Paul, and E. Chilton Phoenix. *Rocks Rails & Trails*. Pocatello, ID: Idaho State University Press, 1994.

Ruckman, Jo Ann. *Pocatello is Our Home*. Pocatello, ID: Idaho State University Press, 1998.

The importance of Pocatello as a railroad junction is shown in this Union Pacific Railroad advertisement from 1963. The main line went west to Portland and Seattle in the Pacific Northwest and east to Omaha, Chicago, Denver, and Kansas City. Other main lines went north to Butte and south to Salt Lake City and Los Angeles. The railroad lines on the map have not changed to this day, although some of the branch lines not shown on this map have been abandoned.

Visit us at
arcadiapublishing.com

Printed in the USA
CPSIA information can be obtained
at www.ICGtesting.com
LVHW010016021123
762837LV00007B/95